S0-CFF-039

ERRITS.

COPY 22

759.04 Mannering, Douglas
M The art of Rembrandt. Excalibur Books,
 c1981. 80p. col. illus.

Livonia Public Library
ALFRED NOBLE BRANCH
32901 Plymouth Road
Livonia, Mich. 48150

19

THE ART OF
REMBRANDT

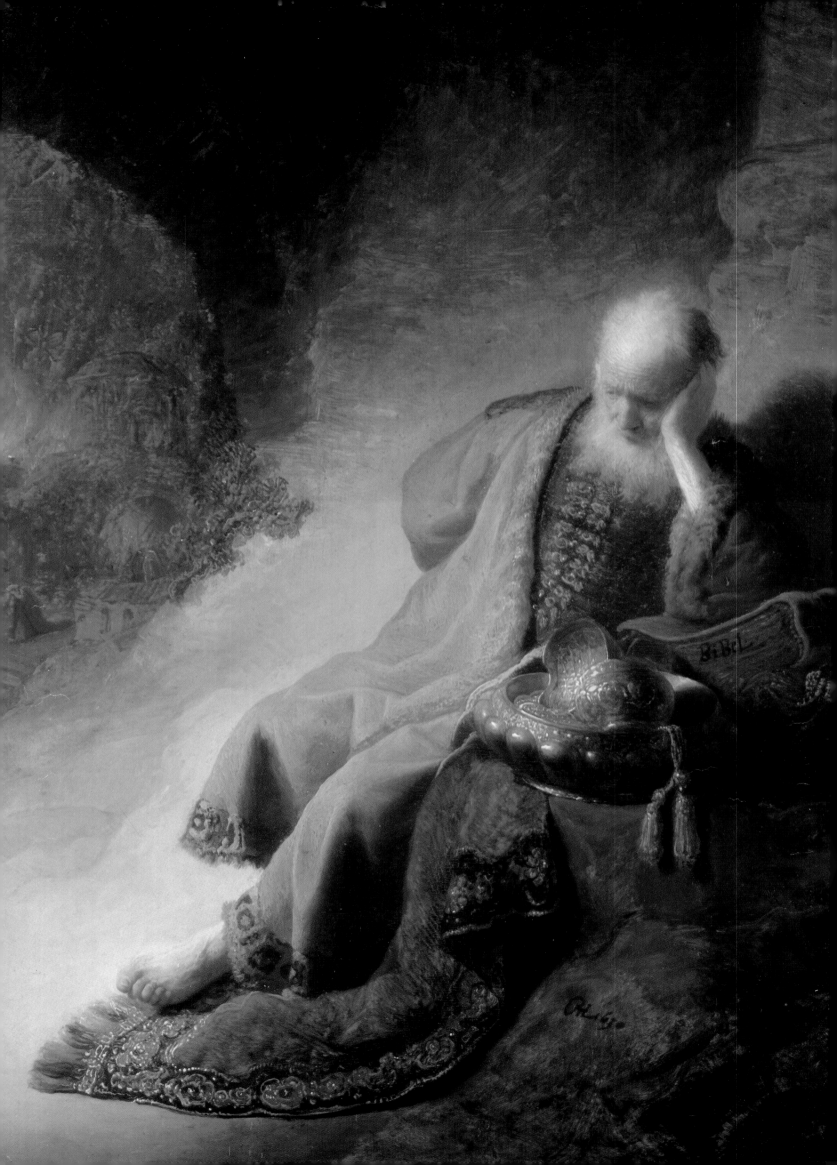

— THE ART OF —
REMBRANDT
Douglas Mannering

EXCALIBUR BOOKS
NEW YORK

Designed by Groom and Pickerill

Copyright © 1981 The Hamlyn Publishing Group Limited

First published in the USA in 1981
by Excalibur Books
Excalibur is a trademark of Simon & Schuster
Distributed by Bookthrift
New York, New York

ISBN 0–89673–091–3

Printed in Italy

Contents

The Greatness of Rembrandt

Rembrandt van Rijn was the greatest Dutch artist of his time, and ranks as one of the master-painters of the world. He worked within the pious Protestant ethos of the 17th-century Netherlands, yet his art has a rare universal quality that is capable of appealing to all men and women.

Paradoxically, this art cannot be appreciated instantly, but requires time, attention, and perhaps a certain maturity. For it is not violent or otherwise dramatic, it has only occasional passages of virtuoso display, and it is sparing of easily identified messages and meanings. Beyond his deep preoccupation with the Bible, Rembrandt takes humanity itself as his subject; but it is not the physically splendid humanity of a Michelangelo, or the rubicund, flamboyant humanity of a Rubens, or even the tortured humanity, so close to God and madness, of a Van Gogh. It is, for the most part, ordinary social humanity such as other Dutch artists of Rembrandt's day were painting — but an ordinary humanity whose unglamorous features are alive with the activity of what can only be called the soul. This quality is not necessarily religious in the strict sense of the word; Rembrandt's portraits, for example, do not tell us whether we are

*Head of a Laughing Man. c.*1630. A small painting on copper. Mauritshuis, The Hague.

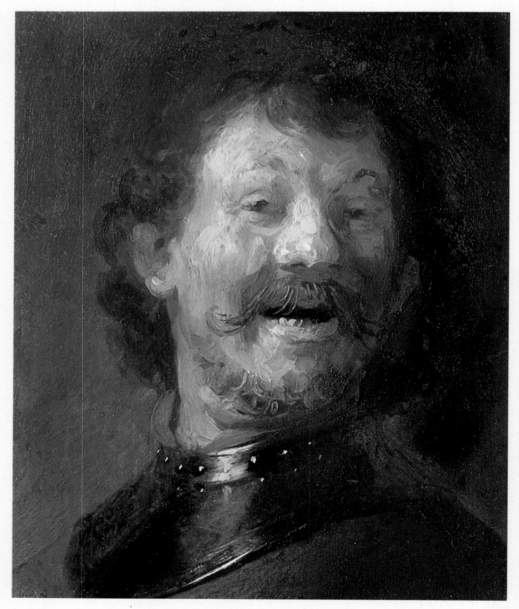

6

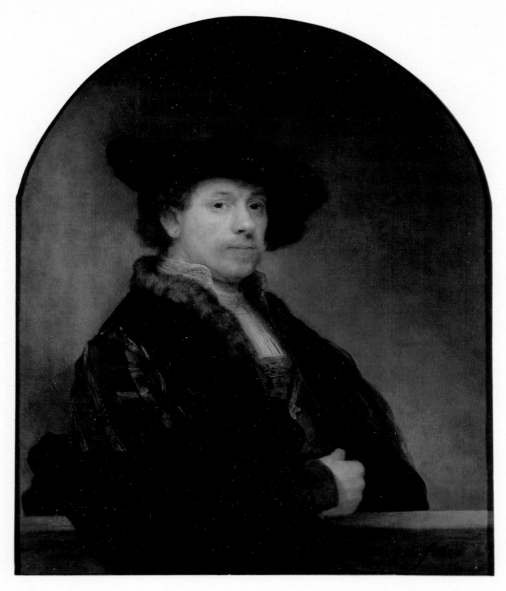

Self-portrait. 1640. Here, at the height of his reputation, Rembrandt's self-image is almost sleek in its comfortable opulence. National Gallery, London.

looking at saints or sinners. But they do show us men and women seen from their deepest and most serious side; they represent humanity at its weightiest, most thought-shadowed, most conscious of destiny and experience, most deserving of respect. Whether Rembrandt saw this quality in others, or gave it to them from his own stock, is another matter. A cynic might claim that he has flattered the human race more subtly and effectively than the most servile court painter or the most idealistic champion of the people.

Rembrandt also scrutinized his own features more intensely than any previous artist, and rendered an equally earnest account of what he saw and divined in them. In one medium or another he portrayed himself over ninety times. By contrast, the average artist painted a single self-portrait, or contented himself with an occasional 'signature' in the form of a likeness of himself placed among a painted crowd; and even the most self-obsessed of earlier artists — the 16th-century German Albrecht Dürer — left no more than a handful of self-portraits. When he was a young man, Rembrandt probably used himself as a model out of a combination of sheer *joie de vivre* and economy; he obviously enjoyed dressing up in rich and exotic costumes, and trying out the expressions he needed to master by pulling faces in a mirror and copying the results. But increasingly, as he got older, his self-portraits became the outer and inner history of a man — at once a faithful record of his ordinary, broad, rather lumpy face as it matured, lined, folded, pouched and fell, and a more elusive record of states of soul, so eloquent that it becomes tempting to over-interpret the self-portraits to expand the little we know about Rembrandt's life.

For all his preoccupations, Rembrandt was a professional artist and, until middle age, a perfectly successful one. Born and brought up in Leyden, itself a thriving little university town, he was able to establish himself as one of the

7

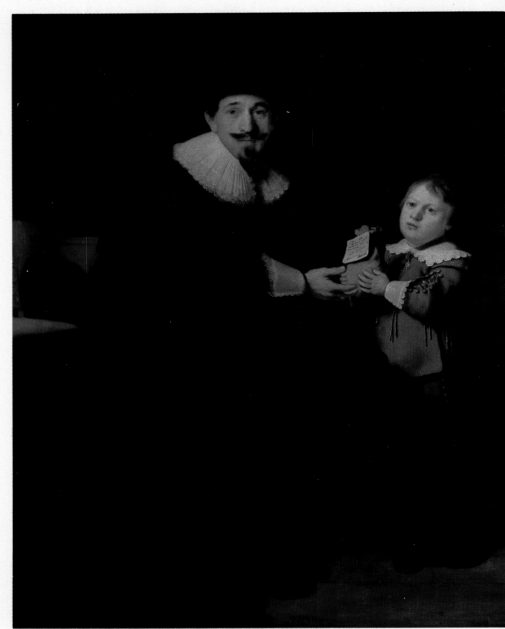

Right: *Jan Pellicorne and his son Caspar*. A portrait of an Amsterdam merchant and his son, probably executed in the early 1630s. Wallace Collection, London.

Below: *The Concord of the State*. 1641. The allegorical content of this painting, intended to convey the unity of the Netherlands, makes it an exception among Rembrandt's works. It is not a finished painting but a preparatory study; however, no other work on the subject exists. Boymans-van Beuningen Museum, Rotterdam.

Susannah van Collen, wife of Jan Pellicorne, and her daughter Eva. The companion-piece to *Jan Pellicorne*. Wallace Collection, London.

leading artists in Amsterdam, the chief city of the Netherlands. He was much in demand as a painter of individual and group portraits, but unlike most other Dutch artists he avoided specialization, painting and drawing landscapes, biblical, mythological and historical scenes, and genre (a portmanteau term covering a variety of domestic and everyday items from a Mother and Child to a Slaughtered Ox). After his death, the legend grew up that his famous group portrait, *The Night Watch*, outraged the people who had ordered it, that Rembrandt's reputation collapsed as a result, and that he spent his last years as an impoverished and forgotten bankrupt. The story typifies the modern tendency to make martyrs and sages out of writers and artists. The truth seems to be less dramatic — that Rembrandt's work gradually ceased to be high fashion, but that he was never without a reasonable number of buyers and patrons; his bankruptcy was caused by mismanagement and, though a serious enough matter, did not plunge him into the depths of poverty. (His older contemporary, Frans Hals of *The Laughing Cavalier*, was much less fortunate; he is said to have ended his life — three years before Rembrandt — as a charity case.) How much Rembrandt's vanity suffered from his partial eclipse, we cannot know; but he seems more likely to have felt deeply the series of personal tragedies that robbed him in turn of his wife, his mistress and his only son.

In certain respects Rembrandt was astonishingly modern. The 17th-century painter was still essentially a craftsman; the starting point of his activity was not the conception of a work of art but the terms of the commission he received from a patron. He might be given more or less freedom to paint what or as he chose, and he might succeed in producing an imperishable masterpiece; but he worked

9

Far right: Frans Hals. *The Laughing Cavalier*. 1624. Wallace Collection, London.

Right: *The Abduction of Ganymede*. 1635. Here Rembrandt is parodying the solemn absurdities of mythological painting: the beautiful boy, carried off by Zeus, king of the gods, in the form of an eagle, becomes a squealing incontinent baby. Staatliche Kunstsammlungen Dresden, Gemäldegalerie Alte Meister.

Below: Drawing of Ganymede. Staatliche Kunstsammlungen Dresden, Kupferstichkabinett.

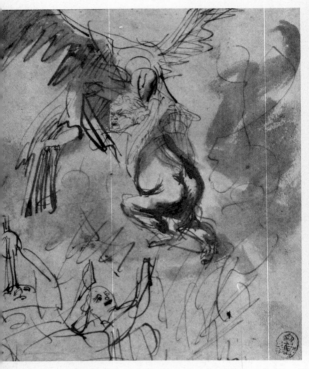

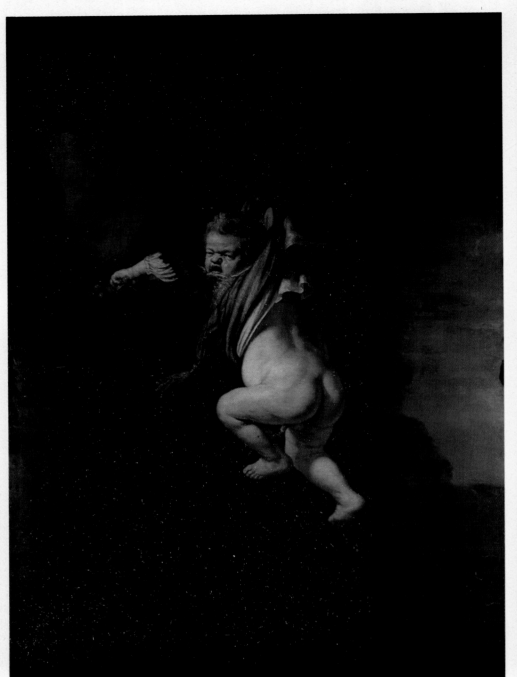

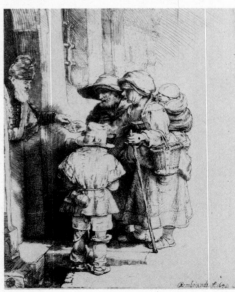

Above: *Beggars Receiving Alms*. 1648. Etching. British Museum, London.

within limits that were imposed from outside. The situation was much the same in the Netherlands as elsewhere, although Dutch painters also had opportunities to sell pictures in some conventional categories on the open market. But the artist as an autonomous figure, following a vision or impulse wherever it led him, without much regard for fashion or the state of the market, did not yet exist and was hardly seen in Europe before the 19th century. Rembrandt appears to have been the first of the moderns in this sense, or at least to have alternated between the 'traditional' and 'modern' modes. His ninety-odd self-portraits are decisive proof of the extent to which his art was inner-directed, but there are also abundant indications that many of his other works (for example, the portraits of his Jewish neighbours) were executed without thought or likelihood of their being sold. It is possible to argue that he would not have done them if he had not been under-employed — and possible to answer that he would not have been under-employed (if he really was) had he cared to work in the manner he himself had taught his own prospering pupils. Insofar as Rembrandt was less than successful in later life, it was because he preferred to follow the path he had chosen for himself.

Technically, too, Rembrandt's work was in advance of its time. A good painting was expected to be highly finished, with a smooth surface on which the brushmarks would be virtually invisible; in a portrait, if every button on a coat or pleat on a ruff was distinctly visible, so much the better. But Rembrandt came to appreciate that the paint itself could be an important element in a picture; the direction of brushstrokes and the varying thicknesses of the paint could create

10

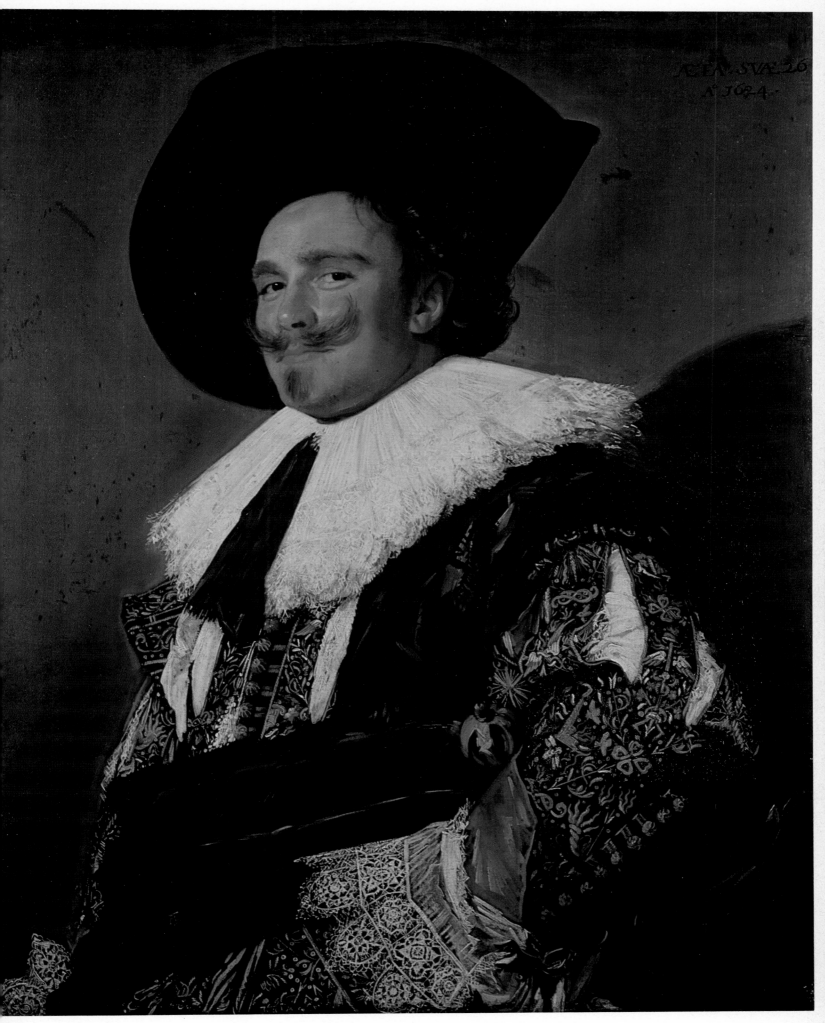

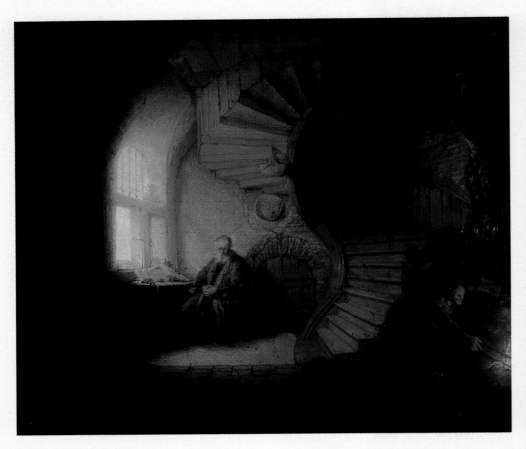

Right: *Scholar in an Interior*. 1633. One of many similar paintings on this subject by the young Rembrandt. Musée du Louvre, Paris.

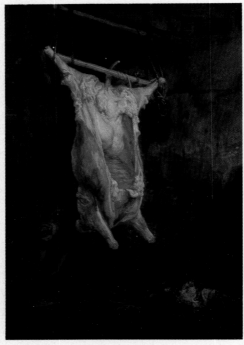

Above: *The Slaughtered Ox*. This was probably painted much earlier than the famous Louvre version of the subject. Art Gallery and Museum, Glasgow.

Far right: *Uzziah Stricken with Leprosy*. 1635. A powerful imaginary portrait of the biblical king, smitten with leprosy as a punishment for his transgressions. Devonshire Collection, Chatsworth, Derbyshire.

patterns and textures that influenced the total feeling of the work — a concept that has become familiar to everybody since the time of the Impressionist painters. Rembrandt was no Impressionist, but his handling of paint was very free by the standards of his time — and in places so thickly applied that a later writer jocularly claimed that it was possible to pick up one of his portraits by the nose!

The more cursory passages of brushwork, so richly suggestive to the modern eye, were not much to the taste of the generations that followed Rembrandt's. His paintings were therefore covered with thick layers of varnish that gave them an artificial smoothness and obscured the brushwork — and the varnish grew more yellow and begrimed over the years. Varnish and dirt made pictures that were relatively dark seem positively murky, giving Rembrandt a reputation that was shown to be false only in recent times, when careful, scientifically conducted cleaning revealed the often rich colours of the original works. However, there was this much to Rembrandt's reputation as a 'dark' painter — that he was the great master of *chiaroscuro*, the manipulation of light and shadow in a painting. This had first been widely exploited by Italian artists, and the dramatic contrasts they obtained strongly influenced a number of Dutch painters, including Rembrandt himself. But in his hands, *chiaroscuro* lost its dramatic character and became a means of subtly modelling the faces of his sitters and enveloping scenes in a richly evocative atmosphere. And so his paintings *are* relatively dark; technique and temperament come together in them to create a grave, shadowed version of the ordinary world, inward and spiritual in interpretation.

The history of Rembrandt's reputation is a curious one, for after his death he was not rated highly and yet was never quite forgotten; writers on art tended to discuss his work, even if only to denigrate it — as if half-conscious that his very existence constituted a challenge to their standards. Sir Joshua Reynolds, for example, spoke for all believers in the Grand Style by being condescending not only to Rembrandt but to all the Dutch painters: 'Let them have their share of more humble praise. The painters of this school are excellent in their own way; they are only ridiculous when they attempt general history on their own narrow principles, and debase great events by the meanness of their characters.' The criticism was most pointedly directed at Rembrandt, whose portrayal, in particular, of biblical men and women — of patriarchs, kings, prophets, apostles and evangelists — broke with the heroic tradition. As often as not, he made them ordinary people — plain, plebeian, even bent or worn — in the grip of God, a

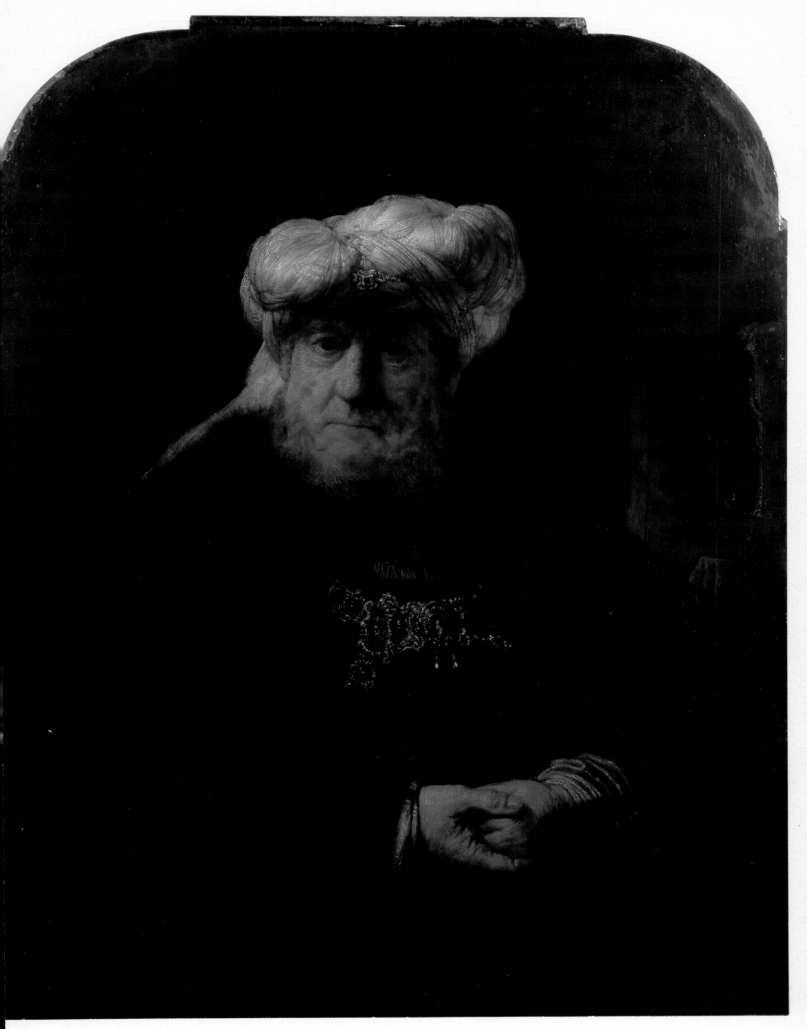

spiritual crisis or the march of events; he even tried to make them look like Hebrews, basing his efforts on studies of his neighbours in the Jewish quarter of Amsterdam. Clearly there was not much in Rembrandt's art to appeal to the 18th century, with its taste for clarity, its emphasis on the social virtues (and vices), and its admiration for a Grand Style that had in fact degenerated into a heroic posturing without an ounce of inner conviction. Yet even Reynolds, the supreme propagandist of the Grand Style, when he came to list half-a-dozen great masters and their imitators, felt impelled to include Rembrandt among the great. He too must have had a feeling that his certainties did not quite cover the whole of artistic endeavour.

The towering reputation now enjoyed by Rembrandt was only established in the course of the 19th century, probably as a result of the new sense of inwardness, individuality and emotion that were part of the Romantic movement. Within fifty years of Reynolds' dismissal of Rembrandt and the Dutch school, we find the Romantic essayist and critic William Hazlitt (himself a failed painter) summarizing Rembrandt's achievement with a point and force that could hardly be improved on:

'If ever there was a man of genius, he was one, in the proper sense of the term. He lived in and revealed to others a world of his own, and might be said to have invented a new view of nature. He did not discover things *out of* nature, in fiction or fairy land, or make a voyage to the moon . . . but saw things *in* nature that every one had missed before him, and gave others eyes to see them with . . . Rembrandt's conquests were not over the *ideal*, but the real. He did not contrive a new story or character, but we nearly owe to him a fifth part of painting, the knowledge of *chiaroscuro* — a distinct power and element in art and nature.'

The Wedding of Samson. 1638. The biblical story of Samson was one of Rembrandt's obsessive subjects. Here he represents the hero propounding a riddle to his Philistine wedding guests. Curiously, the picture is dominated by the isolated figure of Samson's Philistine bride. Staatliche Kunstsammlungen Dresden, Gemäldegalerie Alte Meister.

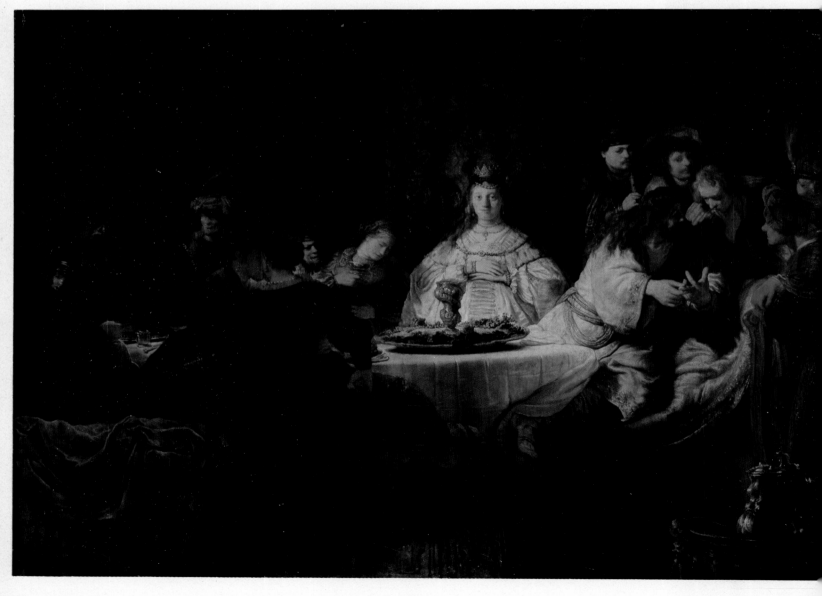

14

The Golden Age of Dutch Art

The 17th-century Netherlands was a new nation-state that had barely won its independence before it found itself one of the great powers of Europe. Then as now, the Continent was the scene of ruthless power struggles complicated by ideological hatred and intolerance — in this case, the hatred and intolerance of Catholic for Protestant, and vice versa. In the late 16th century, the Low Countries as a whole were possessions of the Duke of Burgundy; but their duke was the King of Spain, Philip II, who had determined to end the traditional liberties of the duchy and to stamp out the pockets of Protestant heresy that were appearing in some places. His heavy-handed policy led to the very consequences he feared; rebellion broke out and heresy spread. From the 1570s Philip was engaged upon an attempt to recover his lost territories by military conquest. His Spanish troops were the best in Europe, but they had to cope with difficulties of supply and terrain that slowed their advance. The rebels held the lines of the rivers for as long as possible, and where necessary opened the dykes and flooded their own land to hold up the enemy; and they developed a formidable skill in sea-fighting. They were given aid by the enemies of Spain, both Protestant and Catholic; in fact, the destruction of the Spanish Armada in 1588 was as important an event to the Dutch as to the English. The outcome was that the Spanish conquered only the southern provinces of the Low Countries. The twelve-year truce of exhaustion signed in 1609 (three years after Rembrandt's birth) effectively registered the independence of the seven northern provinces, though formal recognition was not generally granted until the end of a wider European war in 1648 (when Rembrandt was already a man of forty-two).

The boundary between the southern or Spanish Netherlands and the independent north was a purely military one, without an ethnic, a linguistic or — originally — a religious basis. Yet it had the most far-reaching consequences that can be imagined. In the 'Flemish' south, Catholicism was enforced, while the 'Dutch' north became mainly Protestant; gradually, shaped by politics, economics and religion, different 'national' characteristics developed; and the difference thus created has persisted through all later vicissitudes, and survives in the now friendly but still distinctive states of Belgium and Holland. This

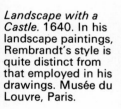

Landscape with a Castle. 1640. In his landscape paintings, Rembrandt's style is quite distinct from that employed in his drawings. Musée du Louvre, Paris.

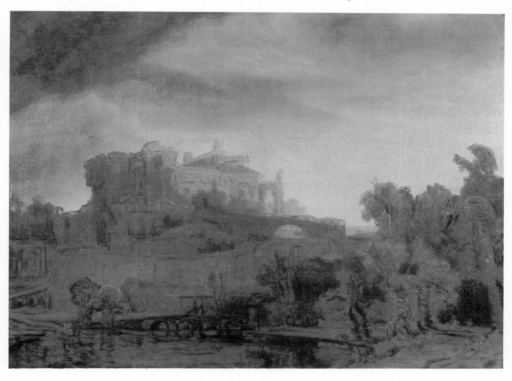

15

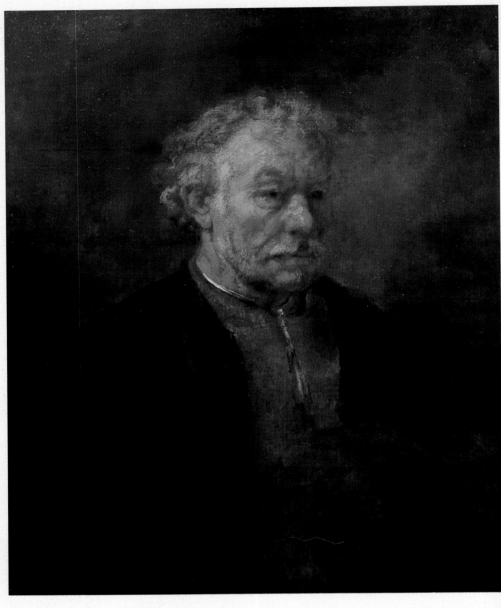

'Rembrandt's Brother'. 1650. Rembrandt painted this man several times, and some authorities believe he was the painter's brother, Adriaen. Mauritshuis, The Hague.

Right: *Portrait of Agatha Bas*. 1641. Rembrandt painted a companion portrait of Agatha's husband, Nicolaas van Bambeek. Royal Collection.

divergence was, if anything, more pronounced in the schools of painting that developed, and showed itself almost at once. Flemish art remained in the central tradition of the European Baroque style, a grandiose and colourful feature of altar and palace that aimed to overwhelm the spectator with a sense of the glory of Church and State. Dutch art developed a characteristic sobriety and intimacy, suitable for a Bible-reading mercantile people who whitewashed the walls of their churches but displayed a marked taste for good, sensible, everyday scenes on the walls of their homes.

Despite their sober art and often equally sober dress and manners, 17th-century Dutchmen were bold seafarers and merchant adventurers who traded and colonized over most of the world. Their shipping dominated the carrying trade of Europe — so much so that they boasted of never having to carry ballast since they could always arrange to ship cargoes on both their outward and return voyages. They supplied western Europe with corn from the Baltic, where every native trader spoke a pidgin-Dutch. Further afield, they seized the East Indies (modern Indonesia), Malacca, Ceylon, and the Cape of Good Hope, and established settlements in the Americas and the West Indies, making high returns on their trade in slaves, spices, sugar and many other commodities. They resisted Spanish attempts to destroy their independence, more than held their own in three naval wars against England, and in the 1670s successfully held out in the face of the powerful French army of Louis XIV. Stimulated by commerce and war, credit and banking practices developed rapidly, and Amsterdam became the financial centre of Europe. It witnessed the first public financial disaster of the modern type, in which frenetic buying and ever-higher prices are followed by a collapse of confidence and panic-stricken selling in a plummeting market — in this case the 'tulip mania' of the 1630s,

16

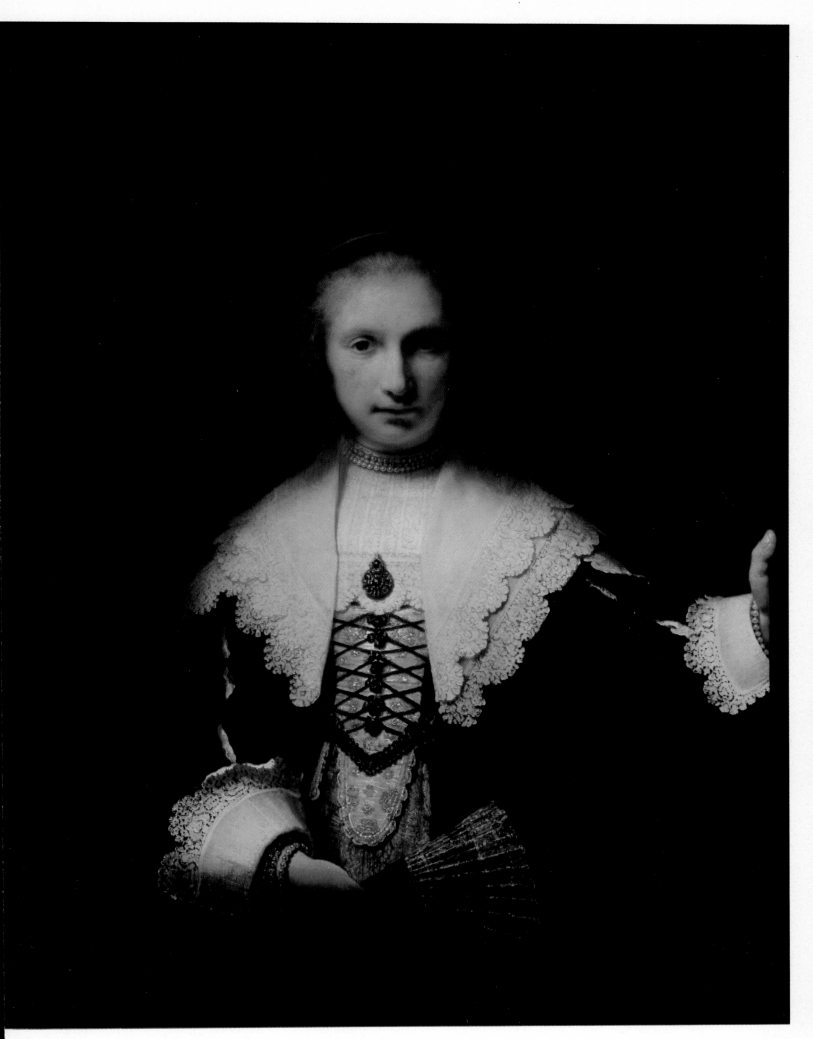

Below: Sheet of studies including Saskia in bed. British Museum, London.

Bottom: *Winter Scene.* 1646. In this small painting, the brushwork has been executed in an extraordinarily rapid, sketchy manner. Staatliche Kunstsammlungen Kassel, Gemäldegalerie.

centred on the commercial exploitation of a flower that now seems as Dutch as Edam cheese but was then a recent import from Turkey.

All this activity means that our image of 17th-century Holland, derived from paintings and surviving monuments, needs imaginative enlargement. We visualize it as a flat land with low straight horizons and huge skies, sparse lines of trees, windmills, placid cows, steeples, long avenues, towns with close-packed, high-gabled brick houses, canals, locks, boats, stolid servants, and solemn merchants and professional men dressed in dark clothes and wearing tall hats; but these familiar images from paintings ignore the Dutch experience of war and adventure, tropical sun and Baltic ice, and they give curiously little indication of the drama, vitality and sheer bustle of Dutch life in the golden age of the Republic. Amsterdam in particular must have been a hectic, cosmopolitan place, alive with rumours and speculations about cargoes and contracts and investments. In Rembrandt's time the city was expanding rapidly; he was only one of many hopefuls who arrived there from the provinces to seek their fortunes. The population was swelled even further by foreigners — mainly refugees from religious intolerance such as Huguenots (French Protestants) and Jews — and like other countries which have sheltered the persecuted, the Dutch Republic was richly rewarded by the extra fund of energies and skills it acquired in the process. (The Dutch version of the Calvinist Reformed Church was the established denomination, but other Protestants were allowed to practise, and even Catholics could worship in private without interference.) By the end of Rembrandt's lifetime the population of Amsterdam had passed 150,000 and the city had been greatly enlarged to accommodate it, spreading out in bands ringed by a concentric pattern of canals. The labour involved was considerable, since numerous piles of Scandinavian timber had to be driven into every square yard of low, soggy land before it was fit to build on — another source of noise and activity with which Rembrandt and his like must have been thoroughly familiar. He himself spent

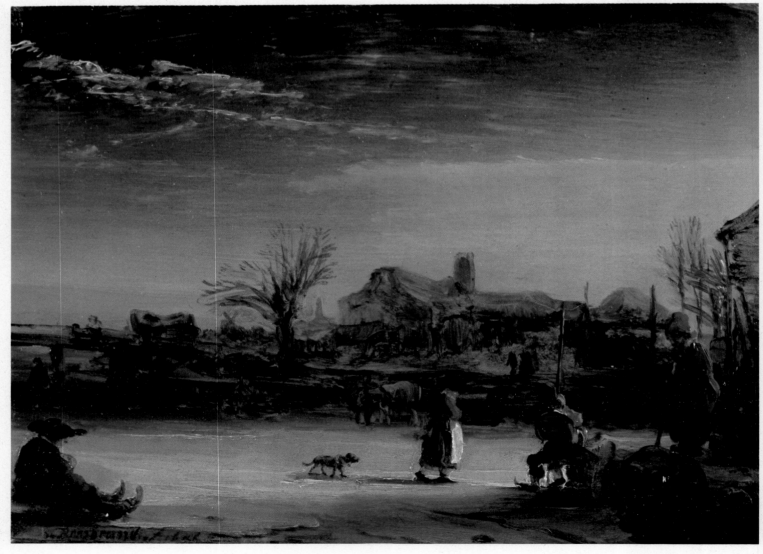

18

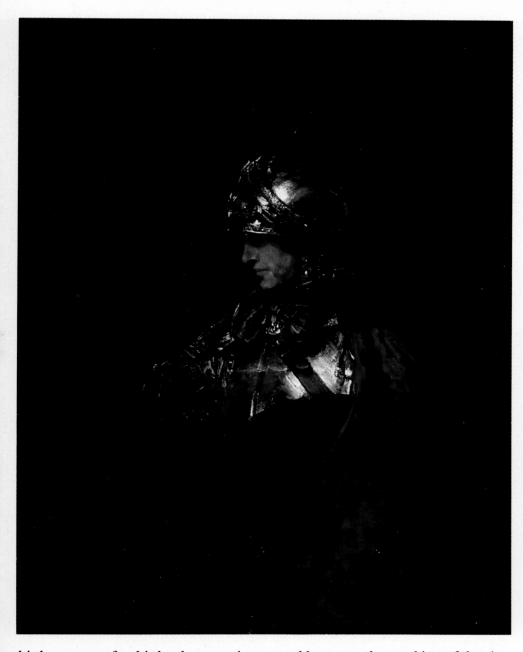

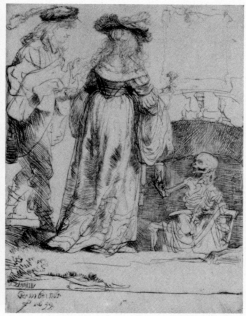

Left: *Man in Armour*. 1655. Possibly an imaginary 'Alexander the Great' painted for Rembrandt's client in Sicily, Antonio Ruffio. Art Gallery and Museum, Glasgow.

Above: *Death Appearing to a Wedding Couple*. 1639. British Museum, London.

his last years, after his bankruptcy, in a rented house on the outskirts of the city.

Rembrandt and other Dutch artists did not inhabit a quiet backwater, whatever facets of the world about them they may have chosen to leave out of their works. Despite the change in religious allegiance, some of them still made the long-traditional study-trip to Italy — the art school of Europe — and later passed on what they had learned to their pupils; one of Rembrandt's teachers, Pieter Lastman, was such an 'Italianizer'. If Dutch artists rarely attempted the full-blooded Baroque style it was not for want of experience or instruction; it was because Dutch taste — the buyers', and probably the artists', too — did not find it congenial. There were other sources of knowledge and inspiration that kept Dutch artists in touch with the outside world. Before the invention of photographic reproduction, prints (etchings, engravings, etc.) performed a similar function, making the works of great masters widely and relatively cheaply available, albeit in monochrome. Since Rembrandt went bankrupt and his possessions were inventoried before they were sold to pay some of his debts, we know that he owned a large collection of prints of works by Leonardo, Michelangelo, Raphael, Holbein, Titian and Rubens, as well as a choice collection of paintings by his Dutch contemporaries. We are also told that he possessed original pictures by Raphael, Giorgione and others, but this is unlikely; they were probably copies or originals by imitators. He owned various plaster casts, including hands, arms and legs, copies of Greek sculptures and Roman emperors' busts and quantities of more or less exotic items that he must have purchased either because they had caught his fancy or because they might come in useful for inclusion in a painting — lions' skins, armour and weapons

19

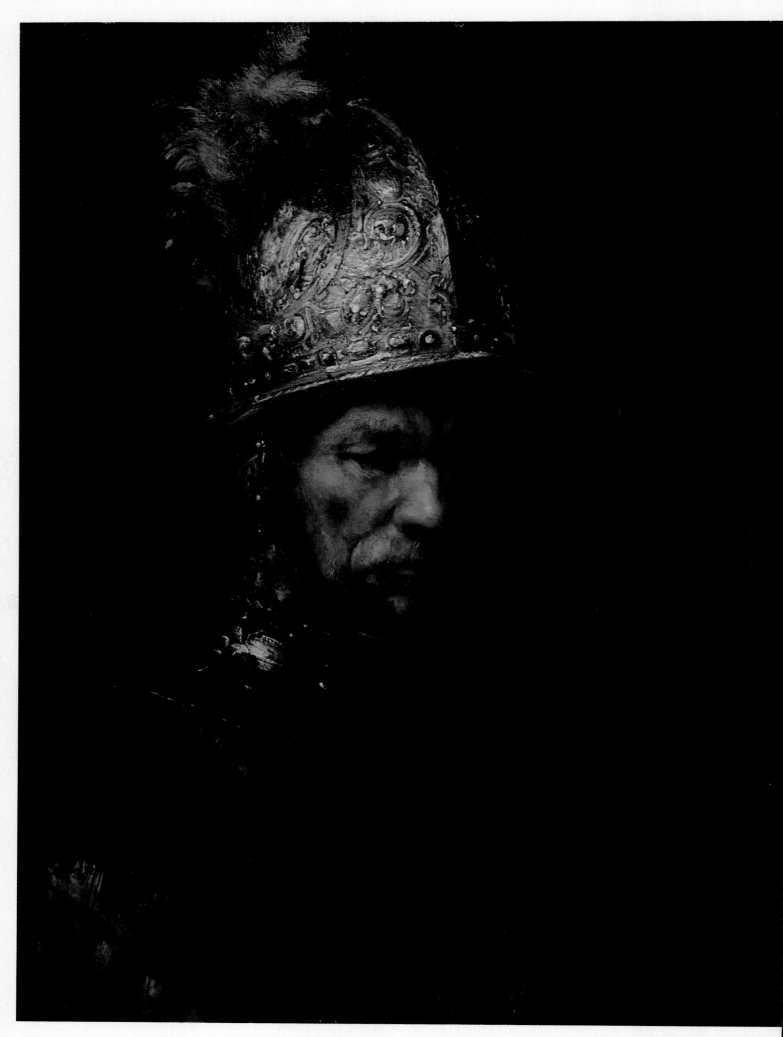

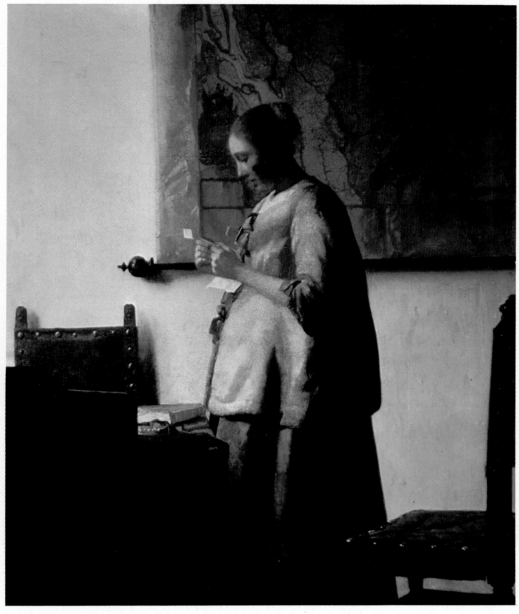

Left: *The Man with the Golden Helmet.* A painting of the early 1650s. The man appears in other paintings attributed to Rembrandt, and it has been claimed that he was Rembrandt's brother. Staatliche Museen Preussischer Kulturbesitz West Berlin, Gemäldegalerie.

Above: Jan Vermeer. *Young Woman Reading a Letter.* c.1665. Only a handful of paintings have survived by Rembrandt's younger contemporary, Vermeer, the great master of light and clarity in Dutch art. Rijksmuseum, Amsterdam.

(including spears, bows and arrows, perhaps from the colonies), curious minerals and creatures, musical instruments, Indian costumes, and even a stuffed bird of paradise from the East Indies. From all this it is apparent that Rembrandt was a connoisseur of European art and general exotica, and there seems every reason to believe that other Dutch artists had a similar breadth of taste and experience.

A fashionable artist could become quite a substantial citizen. Rembrandt's top price was 1,600 guilders — more than the deposit he put down on the grand house in Amsterdam that he bought (for 13,000 guilders) in the days of his prosperity. Later, his fortunes declined. Others, like Hals, ended their lives in actual destitution; and the contemporary obscurity that envelopes several now-famous painters, including Jan Vermeer of Delft, suggests that artists were very much at risk in 17th-century Holland. Technically they were craftsmen, belonging to a guild of the sort that had operated since medieval times as a combined trade union, benevolent society and burial club; in the Dutch version, the Guild of St. Luke's, they were lumped together (incongruously, as it seems to us) with makers of playing cards, print sellers, and other marginally related occupational groups. Guilds were supposed to control the entry of apprentices into the craft, and to maintain a closed shop, but in 17th-century commercial nations such as Holland and England their influence waned rapidly, and it seems unlikely that the Guild of St. Luke's could do much to limit competition or keep up prices in the cut-throat, free-market conditions that prevailed in Amsterdam. Against Rembrandt's 1,600 guilders must be set the *nine* guilders apiece that a highly reputable painter, Jan Steen, received for some of his portraits when he agreed to work off a debt. The painter's calling was evidently an insecure one, and it

21

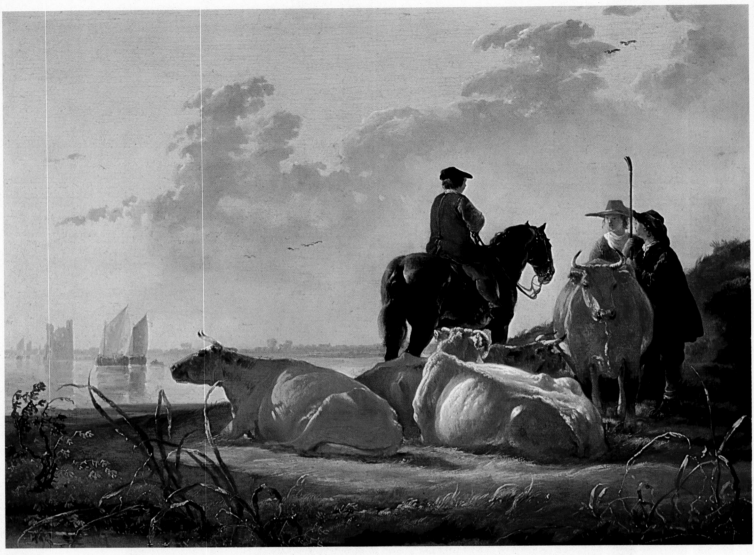

Aelbert Cuyp. *Cattle and Figures*. c.1655–60. National Gallery, London.

is not surprising to discover that many of them had secondary interests as dealers in curios and other artists' works, or even took second jobs as officials or innkeepers.

But if artists were often badly paid, at least the demand for art was great — for paintings and prints, that is; there was remarkably little interest in sculpture, perhaps because it was so closely associated with the 'idolatrous' images that had adorned churches before the Calvinist reformers took power. Instead of being commissioned by kings, courtiers and churchmen, artists sold their wares directly to merchants, officials, professional men and even quite plain folk. Most Dutch householders seem to have had pictures on their walls; great merchants and civic institutions commissioned works from chosen artists, but other people bought them in shops, from the new professional dealers who were appearing, or at markets and fairs. This wide market gave the artist a certain freedom in compensation for his insecurity; unlike the craftsman who worked to order, he could paint what he pleased — provided it also pleased some unknown buyer. As in other commercial practices, the Dutch can claim to have been the first moderns in this respect.

The demand called forth an abundant supply of both paintings and painters. The sheer number of 17th-century Dutch painters is astonishing, even when restricted by the application of some rough-and-ready criterion of 'significance'; we remember Frans Hals, and tend to discount the fact that his two brothers and seven sons were also painters. Other families, such as the Cuyps, Van de Veldes and Ruisdaels produced several artists of some note, running specialist craft businesses that can have been little different in essentials from their medieval counterparts. Dynasties and dynastic marriages remained as important as ever in this intimate professional world; for example, Jan Steen was Jan van Goyen's son-in-law, and Rembrandt himself married the cousin of his fellow-artist, the art dealer and Amsterdam landlord Hendrik van Uylenburgh.

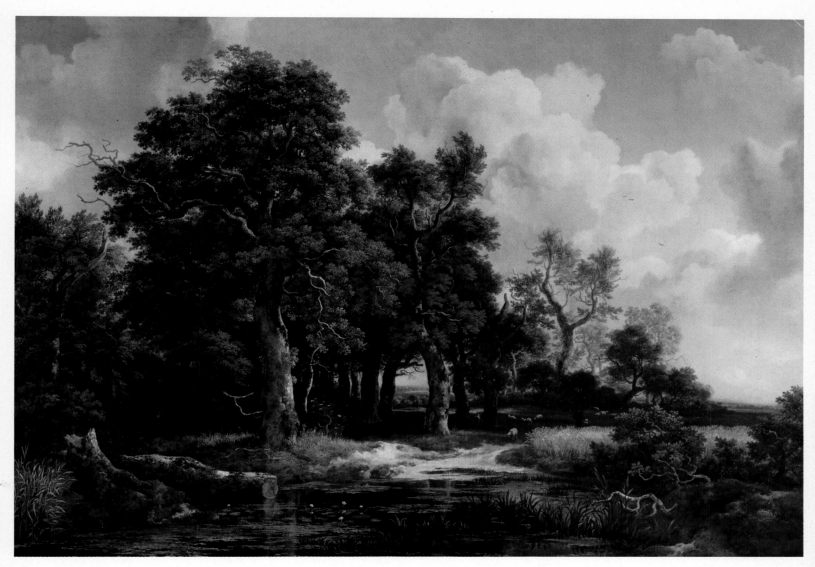

Jacob van Ruisdael. *Wooded Landscape*. *c*.1660. Ruisdael was one of the great pioneers of landscape painting as an independent art of European significance. Worcester College, Oxford.

Although Rembrandt seems to have painted a good deal in response to some inner impulse, he remained an exception. When there were no commissions to hand, other Dutch artists seem to have worked with their potential customers very much in mind; whatever their nominal freedom (including the freedom to starve), in practice their work was largely determined by what people would pay for. The most dramatic change brought by the establishment of the Republic was the virtual disappearance of religious art, which was forbidden in church and not wanted in the home. The ecstasies, apotheoses and agonies of saints and martyrs, along with the cult of the Virgin and everything else that derived from Catholic tradition rather than biblical texts, became anathema; there was therefore no place in Protestant Holland for great wall- and ceiling-paintings, or for the altarpieces so typical of earlier 'Netherlandish' art, in which the donor who had paid for and presented them was rewarded with a humble place in attendance at the painted Nativity. Rembrandt was almost alone in persisting with religious painting, which became increasingly unfashionable even in his strictly Protestant renderings, devoted to Old Testament subjects and the life of Jesus. The puritan ethos of Holland also restricted the demand for mythological or other fanciful types of painting, and in fact tended to make most scenes of violent action or emotion unpopular except, possibly, among a few cultivated admirers of 'Italianizing'.

Given these prohibitions and aversions, Dutch painting was at first dominated by portraiture, in the form of dignified but coolly realistic accounts of the victorious burgher class. The greatest painter of the generation before Rembrandt's was, however, Frans Hals (1580/5–1666), who had an exceptional bravura touch and vein of humour. Though popularly known for his 'laughing' portraits, Hals' most striking achievements are his group portraits. This type of portrait was a distinctively Dutch institution — a painting commissioned by a group of people who usually paid equal shares of the cost. Though popular with boards of governors and directors of all sorts of institutions, it probably

23

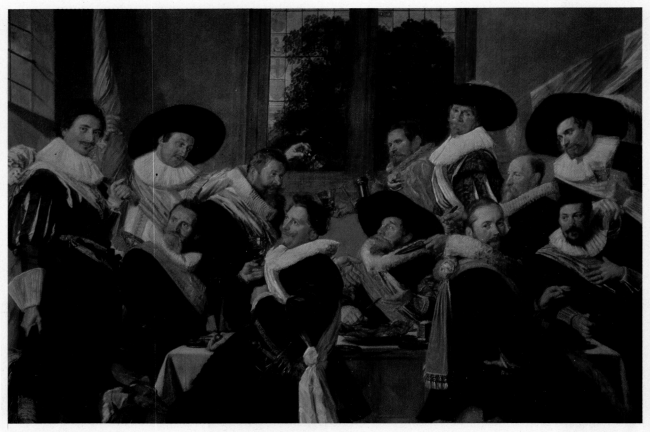

Above: Frans Hals. *The Banquet of the Officers of the St. Hadrian's Militia Company.* 1627. A splendid example of the group portrait. Hals was the great master of this specifically Dutch genre before Rembrandt appeared. Frans Halsmuseum, Haarlem.

Right: Pieter de Hooch. *Boy Bringing Pomegranates.* Wallace Collection, London.

originated in the intense civic consciousness and camaraderie born of the struggle against Spain. Certainly the civic guards — members of the citizen's militia, divided into companies of archers, halberdiers and musketeers — were among the artists' best customers, though by Hals' day their military duties were little more than a memory, and they had effectively turned into social and dining clubs. As paintings such as *The Banquet of the Officers of the St. Hadrian's Militia Company* make pretty clear, the wining was as important as the dining, and the evening often ended in a mild degree of flushed disarray — which certainly made for a better composed picture than a line of heads arranged regularly across the canvas in school-photograph fashion. By ingenious groupings Hals managed to create works of art where others had failed, for the painter's brief — to give equal prominence to every member of the group — was a singularly difficult one, and even he did not always succeed with more sober (and, we suspect from their faces, more self-righteous) groups such as the governors and governesses of almshouses.

Rembrandt, Hals' younger contemporary, was to surpass him as a group portraitist and to excel in every type of work he undertook. During his lifetime (1606–69) Holland began to produce superb specialists of all kinds — painters of portraits and genre (Gerard Dou, Gerard van Honthorst, Gerard Ter Borch), landscapes (Jan van Goyen, Aelbert Cuyp), animals (Paulus Potter), still-life and flowers (Willem Claesz Heda, Willem Kalf), marine subjects (Willem van de Velde); some were even super-specialized, like Hendrick Avercamp, well known for snow scenes with people skating, sleighing and playing games on the ice. Two of Rembrandt's contemporaries, Adriaen van Ostade and Adriaen Brouwer, carried on the old and vigorous Flemish tradition of low-life painting; their scenes of gross peasants and comic drunkenness are not to everybody's taste, but Rembrandt evidently liked them, for he owned seven of Brouwer's pictures before they fell under the auctioneer's hammer. And although Rembrandt was the greatest of 17th-century Dutch artists, he was not the last of the great ones; there was an outburst of genius among his younger contemporaries that set the seal on the Dutch artistic achievement. Pieter de Hooch and, above all, Jan Vermeer painted still, cool, light-filled interiors with an entirely new poetic dimension; while Jacob van Ruisdael and Meindert Hobbema made landscape painting a genre of European significance by bringing a new sense of atmosphere to the Dutch realist tradition. The golden age of Dutch art extended beyond Rembrandt's death, faithful to its sober, accurate, everyday-realistic outlook, until it faded in the early 18th century.

24

Young Rembrandt

Despite their enthusiasm for art, the Dutch felt no great impulse to record the doings of their artists. The evidence about Rembrandt's life is no more scarce than that for most Dutch painters — but this is not saying much. There are plenty of facts concerning him taken from official and commercial documents, as would be expected in a well-regulated burgher state; but evidence of his character, feelings and intentions is extremely sparse. Only seven of his letters survive, all addressed to one of his most important clients, Constantijn Huygens, and mainly concerned with payments outstanding for the work he had done; maddeningly, the single phrase in which he defined his aim as an artist can be understood to mean either 'the greatest and most *innate emotion*' or 'the greatest and most *natural movement*'! The only 'biography' written in his lifetime was a page or so by Jacob Orlers, one of the burgomasters of Leyden, who described the artist's early years in his history of the town, and was not likely to be over-candid about one of her more distinguished sons. For the rest, a couple of biographical scraps written within a few years of Rembrandt's death

Study of a Man's Head. Mauritshuis, The Hague.

were followed at long last by biographies — which appeared late enough in the day for their credibility to have been weakened by the inclusion of serious mistakes that modern research has been able to uncover. Where the material is so slight, even contemporary reminiscences cannot be granted overmuch authority, since a single piece of evidence about a given subject (which may rest on a misunderstanding or an unintentional falsification of memory) proves nothing. When the German painter Joachim von Sandrart writes that Rembrandt — whom he knew — was only semi-literate, we should be wise to suspend judgement for want of confirmation if we did not know that Rembrandt went to a Latin school and matriculated at Leyden University. With these considerations in mind, the reader will realize that this account of Rembrandt's life is made up of facts supplemented by inferences — that is, educated guesses based on the commonplaces of human feeling (Rembrandt went bankrupt; and men do not enjoy going bankrupt), cautiously enlarged by reference to Rembrandt's quasi-autobiographical paintings, etchings and drawings.

Rembrandt Harmensz van Rijn was born on 15 July 1606 at Leyden, then the second largest town in Holland, notable for its industry (weaving mills) and for possessing a university at a time when Amsterdam itself was still without one. Rembrandt's father, Harmen Gerritsz van Rijn, was a miller; the surname 'van Rijn' ('of the Rhine') was taken from the river that ran through Leyden or, at a further remove, from the name of the family mill that stood beside it. His mother, Cornelia Willemsdochter van Zuytbrouck, was the daughter of a baker. The family seems to have been solidly prosperous, if unpretentious; Rembrandt was the only one of the six children that survived infancy who was given the chance to rise in the world. At about the age of seven he entered the Latin school at Leyden, where the Bible and the classics of Roman literature and history were drilled into the pupils. Even if he remembered as little from his schooldays as

27

most people do, Rembrandt is scarcely likely to have emerged an ignoramus; Shakespeare had an almost identical education at Stratford Grammar School — and in their early works both men were fond of subjects and references taken from the *Metamorphoses* of the Roman poet Ovid, long passages of which schoolmasters were inclined to make their pupils learn by heart. He must also have become thoroughly familiar with the Bible, both at school and at home (he portrays his mother in particular as a figure of intense piety); on the evidence of his works it is impossible to doubt his profound immersion in 'the Book', which in vernacular translation was to shape the language and thought of so many Protestant generations. Whether he was more than conventionally pious in the early years of his life is impossible to say.

Rembrandt probably attended the Latin school for the regulation seven years; then in May 1620, when he was almost fourteen, he enrolled at the University of Leyden. The faculties of theology and medicine were already famous, and Rembrandt's parents may have hoped to see him become a minister, a physician

The Rest on the Flight into Egypt. 1647.
National Gallery of Ireland, Dublin.

28

or a government functionary; on the other hand it is possible that Rembrandt matriculated for the sole purpose of acquiring student status and the privileges that went with it, including exemption from service in the civic guard. If he did begin as a bona fide student, he cannot have persisted for more than a few months before he changed direction and opted for a career as a painter.

He then served a three-year apprenticeship at Leyden with Jacob van Swanenburgh, an undistinguished painter of architectural views who had spent some time in Italy. We must assume that Rembrandt learned his basic skills as a painter, etcher and draughtsman from van Swanenburgh, but there is no discernible evidence of the older man's influence in his surviving works; in them, architectural views never appear as the main subject, and van Swanenburgh's other speciality — scenes of Hell — is notable only by its complete absence from Rembrandt's work. According to burgomaster Orlers, Rembrandt's progress was nevertheless so remarkable that his father agreed to let him serve a second apprenticeship to the well-known history painter Pieter

Below right: Adam Elsheimer. *The Flight into Egypt.* 1609. Elsheimer, a German painter who settled in Rome, exercised a strong influence on Rembrandt both directly and indirectly (through Rembrandt's teacher, Pieter Lastman). Elsheimer was fascinated by effects of light, often, as here, deriving from two different sources. Alte Pinakothek, Munich.

Lastman, in Amsterdam. Rembrandt was already about eighteen — too old to undertake another three-year term or to carry out the menial tasks allotted to an ordinary apprentice — so Lastman must have provided something more in the nature of a 'finishing school' course. Rembrandt only stayed with him for about six months, but Lastman's influence on him was deep and enduring. Lastman was a better painter than van Swanenburgh, and had studied in Italy with more profit; his biblical and mythological scenes were brilliantly coloured and vigorously executed. It was he who introduced Rembrandt to the use of *chiaroscuro*, bringing his pupil into contact, at one remove, with the work of the Italian artist Caravaggio, who had exploited the dramatic potentialities of this technique in religious paintings of an intense, often rather repulsive and (by the standards of the time) brutally 'realistic' nature. Rembrandt was to make *chiaroscuro* the foundation of his art, though even in his early work he showed a certain tendency to utilize gently graduated effects of light and shadow, creating atmospheres more reflective than dramatic; his paintings of scholars in lofty, shadowed rooms are examples. Another 'Italian' influence on Rembrandt, experienced via Lastman, was that of the German landscapist Adam Elsheimer, who spent the final decade of his life in Rome; he specialized in very small pictures, painted on copper sheets and notable for their subtle lighting and high finish.

These three influences — Lastman, Caravaggio and Elsheimer — loom large in Rembrandt's early works as a professional artist. After leaving Lastman he returned to Leyden and set up on his own as a history painter. His former teacher's influence is apparent in Rembrandt's choice, since history painting had enormous prestige among Italians and other cultivated people, but was rather less popular in Holland than a number of other genres; portrait painting,

29

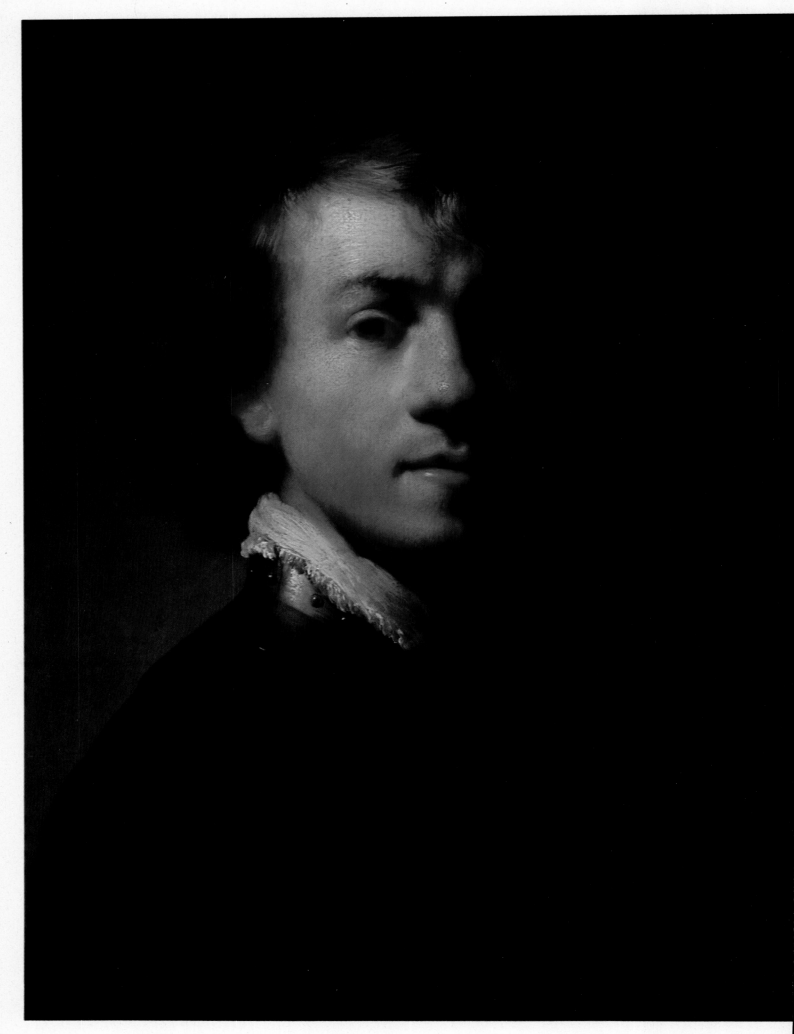

as Rembrandt later discovered, was a far more reliable line of work. In practice, 'history' meant biblical and mythological scenes, plus an occasional scene from ancient Roman history. Rembrandt's earliest datable painting is *The Stoning of St. Stephen* of 1625, in which the violence of the action is displayed with relish, and its claustrophobically enclosed nature is emphasized by the horsemen who ride into the circle of murderers. (It may be significant that Michelangelo used a closely similar arrangement in his *Crucifixion of St. Peter*.) The work is highly competent, if somewhat artificial in the impression it makes, with a crowded background of eccentric architecture and spectators enthroned on an eminence overlooking the scene. For some years Rembrandt was to paint history pictures that were violent and even theatrical — always, arguably, with a certain failure of conviction, as if working against the grain of his own temperament. In his Leyden years, these pictures were very small and mostly painted on panels or copper sheets, reflecting Elsheimer's influence, with glossy, brightly coloured surfaces in the manner of Lastman. There seems to have been a special taste in Leyden for small, highly finished works; Gerard Dou, whom Rembrandt took on as an apprentice in 1628, made a lifelong career in the city as a painter of small, meticulously painted genre works.

While making his reputation as a history painter, Rembrandt was also extending his mastery of *chiaroscuro* in the 'Scholars' paintings and similar works. These are often indirectly lit, and may owe something to another group of Italianizers, the Utrecht School of *Caravaggisti* — followers of Caravaggio such as Gerard van Honthorst who gave their paintings an effective, glowing quality by putting a figure between a candle or lamp and the spectator. Working in this vein, Rembrandt's employment of *chiaroscuro* quickly became more subtle than

Left: *Self-portrait.* c.1629–30. Rembrandt used self-portraiture for many purposes. In this small painting he uncharac- teristically casts himself in the role of the romantic cavalier. Mauritshuis, The Hague.

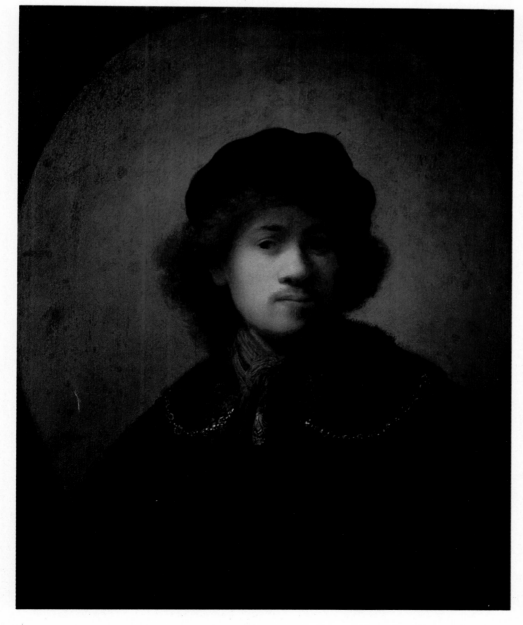

Left: *Self-portrait.* c.1629–30. Walker Art Gallery, Liverpool.

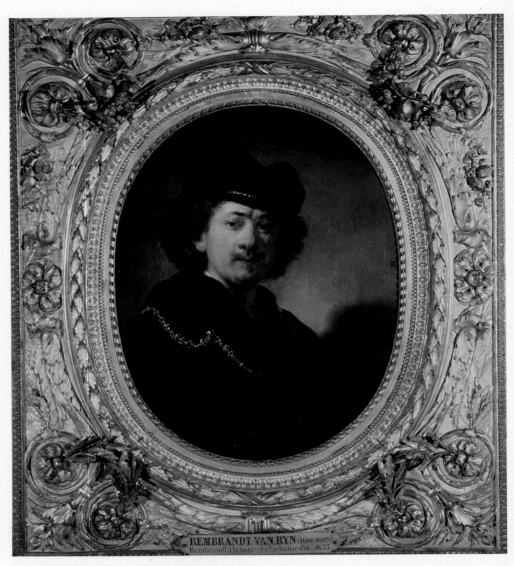

Self-portrait. 1633.
Musée du Louvre,
Paris.

that of his exemplars. He also revealed a preoccupation with old age and experience, and a preference for the ordinary over the idealized face, that was remarkable for an artist still in his early twenties.

No doubt circumstances reinforced his predilections: he continued to live with his parents, who acted as free and generously available models. However, in later life (and even when very well off) Rembrandt continued to use and re-use relatives and acquaintances as models, seeking to achieve greater depth by technique and insight rather than a change of subject. By the late 1620s he had also begun his great series of self-portraits. These too were motivated by a variety of impulses. Some tiny etchings are obviously practice pieces, done to improve his mastery of emphatic facial expressions for his strong-action history paintings. The early painted self-portraits range from self-romanticism, and a naïve delight in dressing-up, to what looks like an attempt to come to terms with his callow, unaristocratic features; in a couple of instances he makes himself look positively bovine, with the fat face and thick pendulous lips of a village idiot.

But although we can see indications of the later Rembrandt almost from the beginning, outsiders were more aware of him as a promising history painter in the grandiose Baroque manner. He was closely associated with another of Lastman's pupils, the slightly younger Jan Lievéns, whose history paintings were so similar to Rembrandt's that contemporaries could not always tell them apart. The two young men often included the same items in their paintings, and are known to have touched up each other's works, so it has been generally supposed that they shared a studio. They were visited at Leyden by the diplomatist and poet Constantijn Huygens, who wrote about them as peers; in Huygens' opinion Rembrandt displayed better judgement and expressive emotion, but Lievens was more inventive and bolder in his treatment of subjects and forms. Huygens was a man of parts — he even painted with some skill — and his patronage of Rembrandt was to be of great importance in the artist's career. But his influence on Rembrandt's work may not have been entirely

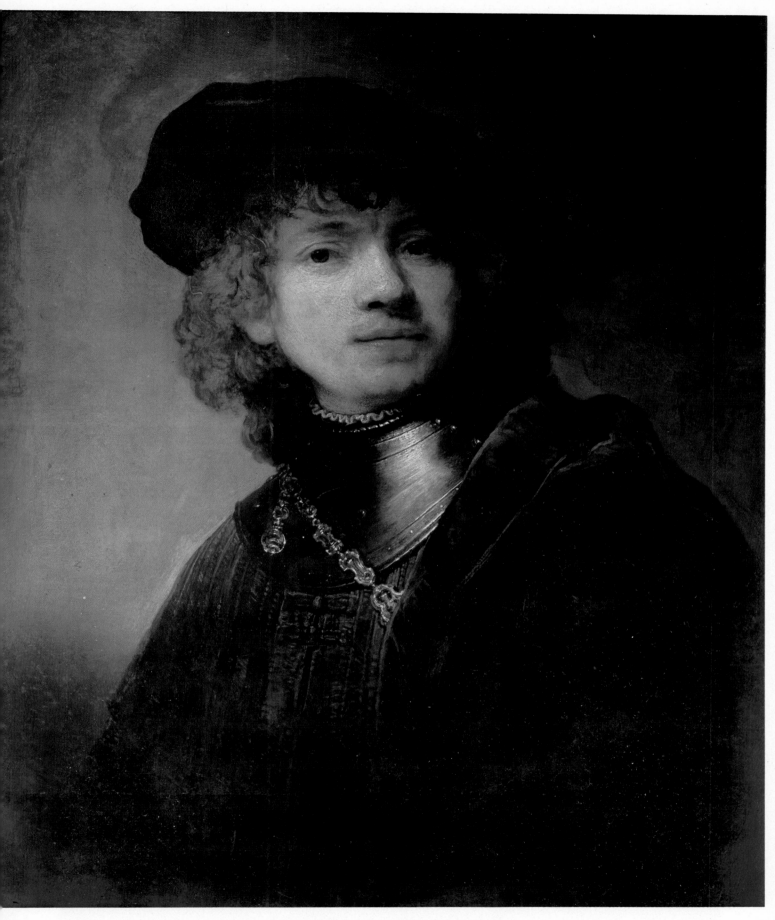

Self-portrait as a Young Man. c.1634. One
of Rembrandt's more glamorized
self-portraits; it has been repainted in places
by a later hand. Galleria degli Uffizi,
Florence.

33

salutary, since he admired the kind of bombastic history painting, full of emotional overstatement, that was not to the general Dutch taste or (more important) the most appropriate medium for Rembrandt's particular genius. Huygens' taste reflected his experience of Europe and his contacts with the nearest thing to a Dutch royal court, the entourage of the Prince of Orange, whose office of *stadholder* made him the permanent generalissimo of the Republic; among his other activities, Huygens acted as the Prince's secretary and adviser on art. Huygens' own favourite painter was the exuberant, larger-than-life Rubens, and his favourite Rubens was a head of the Medusa, one of the serpent-haired Gorgons of Greek myth, the mere sight of whom would turn a man to stone. Rubens' version was so hideous that it inhibited casual viewing, and Huygens kept it hidden behind a curtain. This was the kind of work with which Rembrandt too often attempted to compete in his youth, no doubt spurred on by well-wishers such as Huygens.

Another indication of Huygens' 'European' taste is that he tried to persuade Rembrandt and Lievens to study in Italy, and was disappointed when they refused; both were intent on pursuing their careers, and convinced themselves that there were enough Italian originals and prints circulating in Holland to meet their need for study. However, Huygens remained friendly and encouraging, and the prospect of commissions from him and Prince Frederick Henry of Orange may have decided Rembrandt to seek his fortune in Amsterdam, where he went in 1631 or early in 1632. Soon afterwards Lievens also moved, first to England and later to Antwerp, where he developed a glamorous but relatively superficial style, influenced by the work of Anthony van Dyck, before returning to Holland in 1639. Rembrandt, meanwhile, was making a solid success closer to home.

Jan Lievens. *The Raising of Lazarus.* 1631. Lievens seems to have been a friend of Rembrandt's and to have shared a studio in Leiden with him. The Royal Pavilion, Art Gallery and Museum, Brighton.

34

The Years of Prosperity

The Anatomy Lesson of Dr. Tulp. 1632. Rembrandt's first group portrait was an enormous success, accomplishing the difficult task of giving every participant equal prominence while still producing a work of art. Mauritshuis, The Hague.

At Amsterdam, Rembrandt lodged with Hendrick van Uylenburgh, a painter and art dealer with whom he had already done some business. Van Uylenburgh's house was on the Breestraat ('Broad Street'), in a part of the city that was ceasing to be fashionable among wealthy merchants and was being invaded by successful artists, printers and Jewish immigrants. Rembrandt became a partner in van Uylenburgh's business, which was run from the house and involved employing a team of copyists to reproduce saleable paintings. A landscape or still-life might be copied for sale in the provinces; a more specific work such as a portrait might be wanted in duplicate or triplicate by the sitter, for presentation to his friends and relatives. Such open and legitimate copying has given rise to a host of problems for scholars concerned with authenticity and attributions — many more problems, as far as pre-modern paintings are concerned, than the occasional outright forgery.

Rembrandt's work quickly became worth copying. He probably arrived in Amsterdam with some reputation (perhaps thanks to Huygens), and almost immediately won an important commission from the Guild of Surgeons. *The Anatomy Lesson of Dr. Tulp* (1632) was Rembrandt's first attempt at a group portrait; it succeeded brilliantly, and at once put him at the head of his profession. The occasion it recorded was a public dissection which anyone could

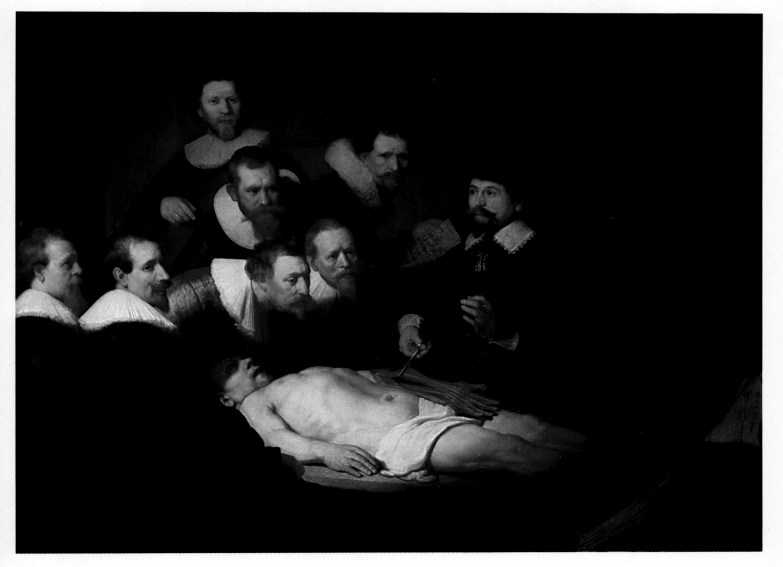

35

attend on payment of an entrance fee; dissection, forbidden during the Middle Ages, was now a respectable professional practice, although the only corpses used were those of executed criminals. Rembrandt's painting, like similar works by other artists, does not show the audience but surrounds the lecturer with admiring colleagues; it is a 17th-century visual equivalent to the modern *Festschrift*, the volume of essays written in honour of an eminent academic by his juniors in the same field of study. Rembrandt has handled the situation with tact as well as artistic skill. Elegantly dressed in black and wearing his hat, Tulp dominates the proceedings; he makes the delicate gesture of a practised lecturer with one hand while using a surgical instrument to hold a tendon in the corpse's arm with the other. His seven colleagues are grouped to one side of him in an irregular pyramidal shape that gives the *Anatomy Lesson* its compositional strength; but they are carefully differentiated so that each is a recognizable individual, distinct from the rest. It is easy to understand why the Guild was delighted with the picture, which gave each of the subjects his due and yet integrated him into a unified action. Though Rembrandt was to paint many equally fine works, it is doubtful whether he can ever have given greater satisfaction to a group of customers.

With this success behind him, Rembrandt remained fashionable and prosperous throughout the 1630s. He received good prices for the dozens of portraits he was commissioned to paint, and is said to have maintained a houseful of paying pupils. On leaving Leyden, where so many of his works had been no more than a foot (30 cm) high, he had begun to work on a dramatically different scale: *The Anatomy Lesson of Dr. Tulp* was roughly 7 feet by 5 feet 6 inches (213 cm by 168 cm), and the portraits of the 1630s were generally life-size. No

Portrait of Saskia. In 1652 Rembrandt sold this fine portrait of his first wife to his friend Jan Six. Staaatliche Kunstsammlungen Kassel, Gemäldegalerie.

36

Saskia van Uylenburgh. 1635. National Gallery, London.

doubt the main reason for this was the different fashion prevailing in Amsterdam, but economics were probably a factor; the newly prosperous Rembrandt, like his big-city clients, could afford the larger scale, and his private self-portraits increased in size just as his commissioned works did.

Rembrandt's marriage was another step up the social ladder. The girl was someone he must have known well — Saskia van Uylenburgh, the niece of his partner and landlord, on whose premises the couple must have met. Saskia's father was a wealthy leading citizen of the town of Leeuwarden, and she also had money of her own; so Rembrandt was the better off in both cash and contacts after his wedding in June 1634. Standards of beauty change over time, and it is difficult to know how attractive Saskia seemed to her contemporaries. In our eyes she looks her best at twenty-one, in a little drawing Rembrandt made of her when they were formally betrothed, in June 1633; for once, the facts are not in doubt, since the painter himself has noted them on the drawing. Saskia, in a big hat with a flower-ringed crown, looks charmingly pensive, as though dreaming of a happy future; one hand lightly supports her head, the other holds a flower. Rembrandt portrayed her many more times, often in association with flowers. In two paintings done in the early years of the marriage, she is still a young girl, appropriately shown as Flora, goddess of flowers and the spring; half-a-dozen years later, in the last portrait of her Rembrandt is known to have painted in her lifetime, she is already a matron, but she looks with tender gravity at the artist/viewer, and holds out a flower to him. If the atmosphere of the paintings is anything to go by (a reasonable but not unshakeable assumption), Rembrandt's marriage was one of affection as well as advantage.

37

Right: *Self-portrait with Saskia on his Knee*.
*c.*1635. Rembrandt appears as a cavalier
merry-maker with his wife on his knee.
Some authorities think that Rembrandt
intended to represent the self-doomed
Prodigal Son of the New Testament parable.
Staatliche Kunstsammlungen Dresden,
Gemäldegalerie Alte Meister.

Above: *Saskia as Flora*. 1634. A portrait of
Rembrandt's first wife in the guise of the
goddess of flowers and the spring.
Hermitage Museum, Leningrad.

An equally reasonable assumption is that he lived extravagantly, or at least
managed his money badly — reasonable, since he earned large sums for a decade
or more, and yet failed even to pay the instalments due on his house. It has been
suggested that Rembrandt had a parvenu's delight in showing off, that Saskia
encouraged him in extravagance, and that he felt impelled to compete with his
rich relations. But none of these is more than a speculation. The earliest
evidence of any kind comes from an Italian priest called Filippo Baldinucci, who
wrote the first significant account of Rembrandt's life. It was published in 1686,
already fifty years after the period of his supposed extravagance, but it fits in
with what we know about Rembrandt's large collection of pictures and other
impedimenta. According to Baldinucci, Rembrandt was a confirmed attender
of auctions, at which he regularly over-bid from the start, in order to head off
opposition and increase the prestige of his profession. (This last phrase has the
ring of an authentic memory; it is just the sort of reason a man might offer to
excuse and conceal the operations of his vanity.) Baldinucci's informant par-
ticularly remembered Rembrandt's taste for picturesque clothing, however old
and dirty, and this too is plausible, since his works show that he enjoyed dressing
himself and others as cavaliers and 'Oriental' types. But it does not go very far
towards solving the mystery of Rembrandt's 'extravagance'; and since there is
not the slightest evidence that he was dissipated or even highly convivial, we are
never likely to know just what he spent his money on.

The impression of extravagance and opulence is strengthened by the way in
which one side of Rembrandt's art developed during the 1630s. As a history
painter he embraced the Baroque style at its most tumultuous and colourful, no
doubt partly in response to the taste of his patrons, Constantijn Huygens and

Prince Frederick Henry of Orange. Its exuberance may have chimed in with his own mood, if we can take *Rembrandt and Saskia* as evidence; in this cheerful double portrait Rembrandt depicts himself as a jolly cavalier flourishing an absurdly long beaker of wine while his wife sits on his lap. (Some authorities see the painting as belonging to the 'Prodigal Son' convention, in which the foolish, erring Prodigal is shown in a tavern with a wench on his knee; and if this interpretation is correct, Rembrandt's work is intended to admonish rather than enliven the spectator. However, Rembrandt seems rarely to have included secondary meanings in his paintings, let alone those that contradict the atmosphere of the scene *as* a scene; so the case has not been proven.)

In the 1630s, Rembrandt's work for the Prince of Orange included a series of paintings on the Passion, intended for the Prince's chapel. The commission may have been a burdensome one, for Rembrandt took several years over it, speeding up only when he needed money. In the five canvases that survive, the change in styles between the *Raising of the Cross*, the *Entombment* and the *Resurrection* is striking. The *Entombment* in particular is shown as a real event, too serious for theatricals; it is as if Rembrandt had begun to tire of his unnatural role as a Baroque dramatist. However, he must have felt grateful to Huygens — or still dependent on him — for in 1636 he presented the secretary with a huge canvas that was obviously meant to satisfy his taste for horrors. In *The Blinding of Samson* the horror approaches the grotesque, with a wildly struggling Samson held down by soldiers while a triumphant Delilah rushes away, carrying a pair of shears in one hand and a great wad of Samson's hair in

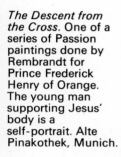

The Descent from the Cross. One of a series of Passion paintings done by Rembrandt for Prince Frederick Henry of Orange. The young man supporting Jesus' body is a self-portrait. Alte Pinakothek, Munich.

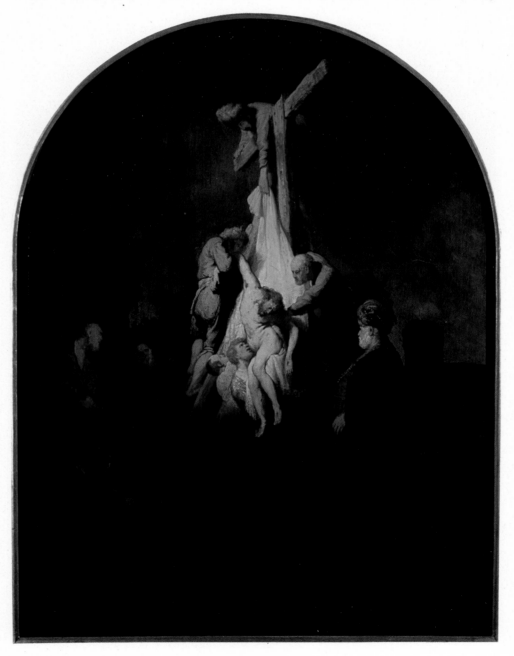

39

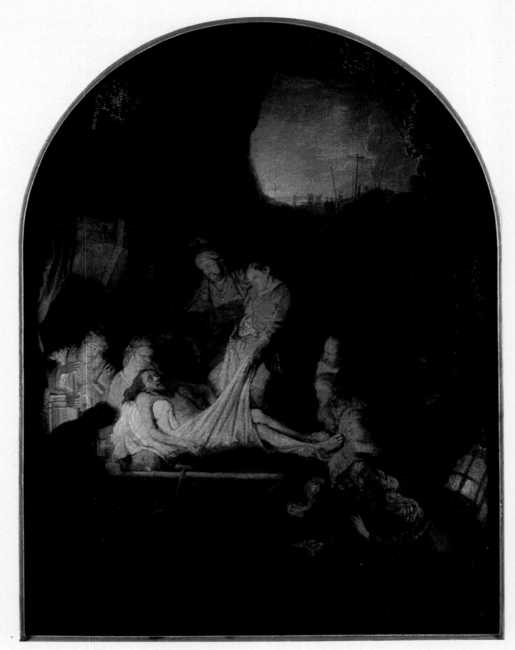

The Entombment of Christ. 1636–39. One of the Passion series done for Prince Frederick Henry of Orange. In a letter dated January 1639 Rembrandt announces that he has finished the 'Entombment'. Alte Pinakothek, Munich.

the other; the hero's eye spurts blood as it is penetrated by a dagger held in an armoured fist. This is perhaps the most un-'Rembrandtesque' picture he ever painted. Curiously enough, it failed to please Huygens, who refused it even though it was a gift.

The gulf between *The Anatomy Lesson of Dr. Tulp* and *The Blinding of Samson* is an extraordinarily wide one that demonstrates how great a range of skills Rembrandt could command. As a popular portraitist he was able to give his clients what they wanted – a good likeness, down to the last button, treated with enough *chiaroscuro* to make them seem dignified and serious. And as an etcher he was known for at least one quality rarely found in his painting, a downright realism that was touched, on occasion, with coarse humour or satire. Part of the reason was doubtless that etching was a more popular art than painting, since prints were of course much cheaper to buy.

Etching was easily the most sophisticated of the various ways of printing illustrations. The crudest of all was the woodcut, used in thousands of early printed books and broadsheets; it was made by cutting away areas from a block of wood to leave a relief design on the surface, which was then inked and printed by being pressed onto paper. In other words, the 'positive', uncut part of the block created the printed impression. By contrast, engraving was done with a metal plate (usually copper) which printed the 'negative', cut-away areas. This was effected by inking the plate and then wiping the surface clean, so that only the grooves and hollows retained any ink; heavy pressure on dampened paper ensured that the required impression was obtained. The engraver, unlike the

40

woodcut artist, was therefore able to 'draw' directly onto the plate by cutting his design into it, line by line, with a narrow-pointed tool (the burin or graver); this made it possible to achieve a fineness of detail that the woodcut could not rival. But scoring metal with a burin nonetheless restricted the variety and, above all, the fluidity of line that it was possible to achieve. Etching, Rembrandt's preferred technique, overcame the difficulty in an ingenious fashion. The artist covered his metal plate with a film of wax, and then drew in the wax with a needle; the 'engraving' was done by immersing the plate in a bath of acid, which bit into the metal wherever it had been exposed by the artist's needle. Printing was then done by the same method as for engraving. The ease, freedom and delicacy with which the needle could be employed was only one of the advantages of etching — for example, the operation of the acid could be controlled by removing the plate and stopping some lines with wax while drawing in new ones before re-immersion — and such procedures could be repeated as many times as the artist chose. Rembrandt frequently produced several versions of a print (called 'states') from a single plate, altering not only

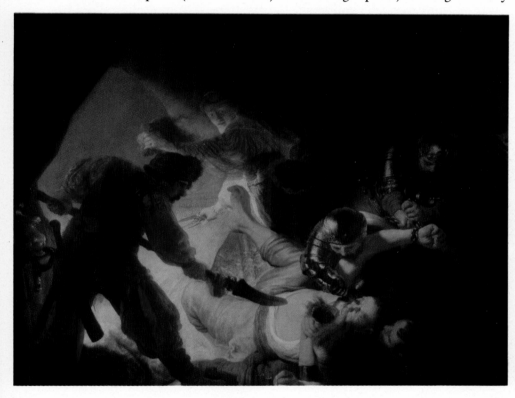

Left: *The Blinding of Samson*. 1636. A painting of extraordinary and uncharacteristic violence, probably intended to satisfy the rather lurid taste of Rembrandt's patron, Constantijn Huygens. Rembrandt made him a present of the picture, which Huygens declined. Städelsches Kunstinstitut, Frankfurt.

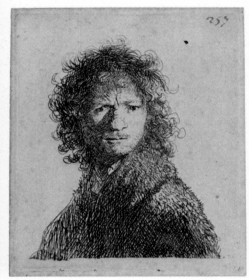

Above: *Self-portrait*. 1630. A wild and woolly Rembrandt appears in this etching, which represents yet another aspect of the artist's lifelong exploration of himself and his means of expression. British Museum, London.

the treatment of the picture but also its contents — putting a hat on a bare head, or a chimney-pot on a roof. He was virtually the first artist to exploit the specific qualities of etching instead of treating it as a less laborious alternative to engraving. Among his earliest self-portraits are a set of very small etchings done with a nervous line that gives them an original 'sketchy' quality.

Rembrandt's earliest biographers, Baldinucci and Houbraken, wrote about his etching technique as though it involved a secret discovery of some kind, but the truth was that nobody had ever before used the etching needle so spontaneously, or exploited the rich *chiaroscuro* effects it could give; on occasion Rembrandt created a series of 'states' in which the shadows grew ever larger and darker until they almost engulfed the scene. Many of his etchings in the 1630s, for example *The Annunciation to the Shepherds*, are comparable in richness of treatment and ambition to the history paintings so much admired by his aristocratic patrons. But in his etchings he also tackled popular subjects that were ignored in his paintings. The poor and none-too-respectable appear in the form of beggars, street vendors and low professionals such as the *Ratkiller*, rendered with more than a touch of grotesquerie. Even more remarkable is Rembrandt's treatment of conventional ideas of beauty in etchings such as *Nude Seated on a Mound*, which parodies the nude beloved of the Renaissance masters by showing us a slack-bellied, coarse-fleshed, vast-buttocked creature in ungainly repose. Prints of this sort had a wide sale, so it is dangerous to make too much of Rembrandt's 'anti-classicism'; he may simply have been meeting a demand — to the disgust of some connoisseurs and collectors a few decades

41

later, who found incomprehensible any conception of Woman that was not couched in terms of Ideal Beauty. However, Rembrandt's debunking is done with gusto, and it is likely that he shared the ordinary Dutchman's taste for an occasional overdose of earthiness. It is also true that the women in his paintings are not ideal types in terms of physical beauty, whatever the other qualities Rembrandt may endow them with.

Materially speaking, Rembrandt's fortunes must have been at their height in 1639, when he and Saskia moved out of rented accommodation into a new home of their own at Number 4 Breestraat, just around the corner from Rembrandt's sometime landlord Hendrik van Uylenburgh. The new dwelling was a substantial building — a 'double house' much wider than most of the neighbouring houses, and consisting of three storeys and a semi-basement. The purchase price was 13,000 guilders, which Rembrandt contracted to pay in instalments — 3,250 guilders over the first year, and the rest within roughly the following five years. It is often said that buying the house led to his ruin, but this is true only in the sense that he failed to pay the sum outstanding and was eventually foreclosed. The price was not unreasonable, and ought to have been within his means. There was plenty of money coming in. He wrote a letter to Constantijn Huygens suggesting that 1,000 guilders would be a fair price for each of the Passion series but indicating that he would accept 600; and at this time he had

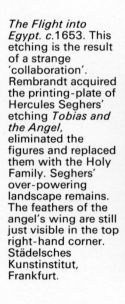

*The Flight into Egypt. c.*1653. This etching is the result of a strange 'collaboration'. Rembrandt acquired the printing-plate of Hercules Seghers' etching *Tobias and the Angel,* eliminated the figures and replaced them with the Holy Family. Seghers' over-powering landscape remains. The feathers of the angel's wing are still just visible in the top right-hand corner. Städelsches Kunstinstitut, Frankfurt.

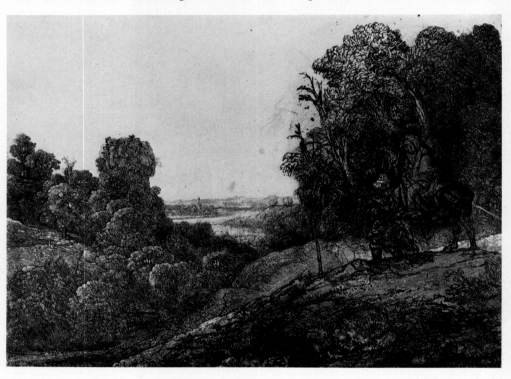

so many pupils, each paying him 100 guilders a year, that he had rented a warehouse as a teaching academy to hold them all. Three years after buying the Breestraat house, he was paid 1,600 guilders for *The Night Watch* (admittedly a very large painting), and he remained a fashionable and outwardly prosperous figure for some years after that; so there is no accounting for his failure to stay out of debt except a guessed-at fecklessness or overconfidence in the durability of his earning power.

In the immediate future there were other, more personal problems. Saskia gave birth to three children, all of whom died in infancy (not, of course, an uncommon occurrence in the 17th century). In September 1641 she bore a son, Titus, who survived; but Saskia herself died nine months later. Rembrandt had painted and drawn her many times, tenderly but truthfully recording the effects of age, labours and illness on her features. In 1643 he painted one last, post-humous portrait of her, finely dressed; but even this parting salute must be nothing less than the truth about her, for it shows her with the strained, worn face of an ailing middle-aged woman.

Saskia's will can be regarded as evidence for the view that Rembrandt was incompetent and extravagant with money. Titus was to inherit her estate when he came of age; Rembrandt was not permitted to touch the capital, though in the meantime he could spend the income from it — but only while he remained

a widower. This last stipulation may have been motivated by posthumous possessiveness on Saskia's part, but it is more likely that she simply hoped to protect baby Titus from having his money spent by a step-mother and step-brothers or sisters. (*Cinderella* is one of many traditional stories picturing step-relations as cuckoos in an orphan's nest — probably a common situation in the high-mortality free-for-all of pre-industrial society.) As money grew tighter, the prospect of losing the extra income from Saskia's estate must have seemed increasingly grim; and we shall see that this consideration may have had a decisive influence on Rembrandt's later life.

In the year Saskia died, Rembrandt painted one of his most famous works. *The Night Watch* has been so called for more than 250 years, and no other title is now likely to become widely used; yet the picture is not a night-piece, and the armed men in it do not constitute a watch or patrol of any sort. They are Captain Frans Banning Cocq, Lieutenant Willem van Ruytenburch and other men of the civic guard, falling in before marching in a parade or to a shooting-match. *The Night Watch* was Rembrandt's second group portrait, commissioned by the guardsmen, and, with one exception, the largest painting he ever executed — originally about 13 by 16 feet (396 cm by 488 cm). After hanging in the Hall of the Civic Guard until 1715, it was transferred to Amsterdam Town Hall, where it was cut down on all four sides to fit the wall space available. By comparing the

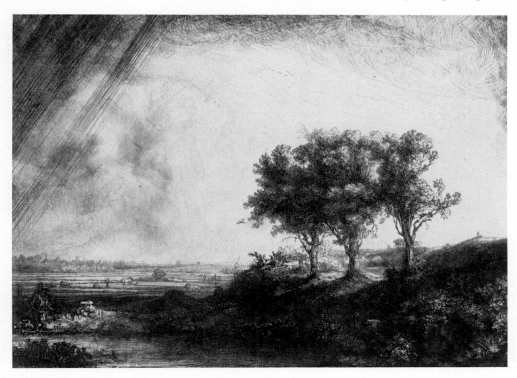

The Three Trees. 1643. This etching is much more sombre than Rembrandt's other landscapes in the medium. British Museum, London.

original with copies made before 1715, we can appreciate the effects of the cutting-down. The most substantial loss was about one foot (30 cm) from the left-hand side, but the most serious was the much narrower strip trimmed from the bottom; its absence brings the whole group forward, concentrates the attention on the captain and lieutenant right up in the foreground and, in combination with the other cuts, crowds the scene and makes it bear in on the spectator a little more than Rembrandt intended. *The Night Watch* is too great a painting to be spoiled by the slight change of balance and emphasis involved, but — we should dearly love to see it in its original state.

One effect of time *has* been partly reversed. Varnish, dirt and smoke darkened the sunlit street of Rembrandt's painting until it came to be thought of as a night-time study; and only a careful post-war cleaning convinced the world at large that the truth was otherwise. It is still a 'dark' picture in that Rembrandt has made extensive use of *chiaroscuro* to dramatize the scene; but there is also plenty of light and colour in it. Rembrandt never achieved — perhaps never wanted to achieve — the kind of swirling, tumultuous, highly emotional painting characteristic of the international Baroque style, though in works such as *The Blinding of Samson* he tried to emulate its violence and excess. *The Night Watch* is also, in its way, a salute to the Baroque — colourful, dynamic, public art but tempered by a certain inescapable national and personal sobriety. It was to be

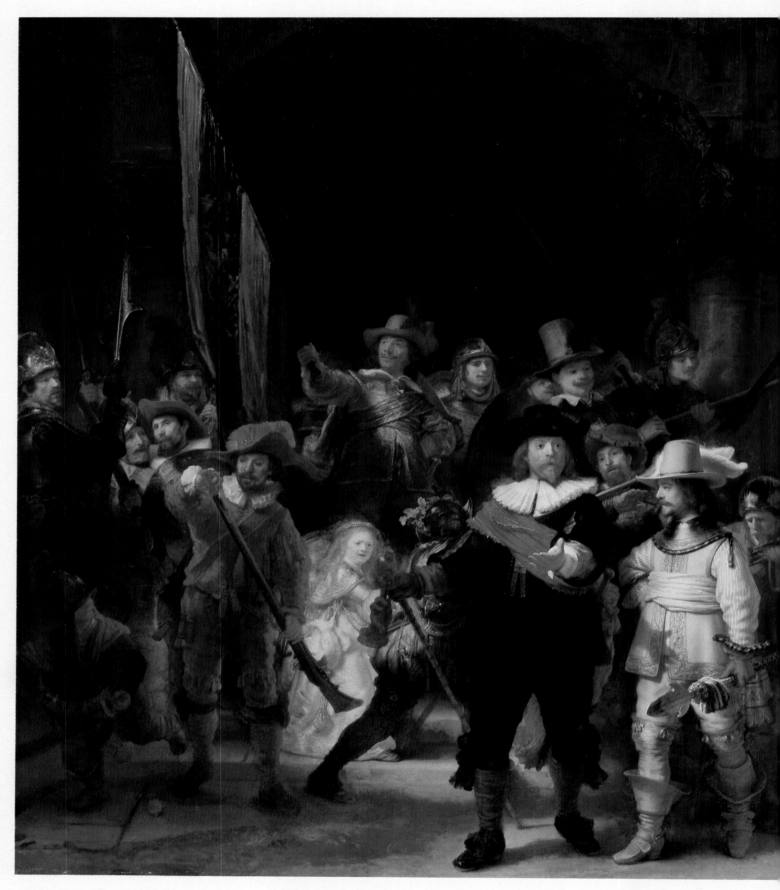

The Night Watch. 1642. Despite the traditional title, this famous painting is not a night-piece. It shows a company of the Amsterdam civic guard falling in before marching away – not to war, despite the flattering dramatization of the occasion by Rembrandt – but to some ceremonial or social event. Rijksmuseum, Amsterdam.

a farewell too, whether intentionally or otherwise, for Rembrandt never again painted anything in a manner so flamboyant that it could possibly be called Baroque.

The Night Watch was like no other corporate group portrait that had ever been painted in Holland. Instead of the equal attention they expected, the civic guardsmen were given widely different prominence; the captain and lieutenant stand at the very front, making a great show of their splendid costumes, while the unluckiest of their men is merely glimpsed over a halberdier's shoulder.

44

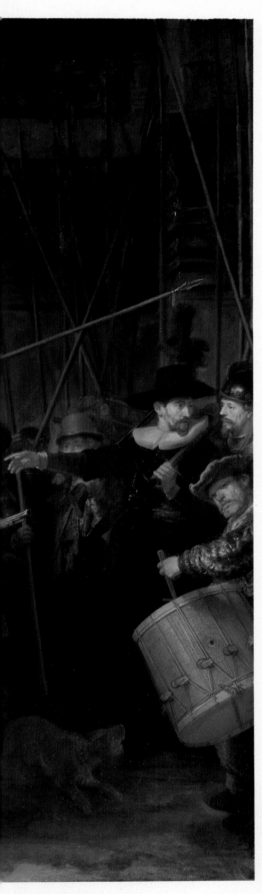

Furthermore, there are a number of non-paying guests in the picture, including an elegant little girl in an embroidered yellow dress with a dead bird hanging from her waist, and an odd, diminutive armoured figure (a boy? a dwarf?) firing a musket near the lieutenant's yellow plumed hat. These unusual features, combined with the later darkening of the painting and the known fact that Rembrandt eventually went bankrupt, seem to have given rise to the legend that *The Night Watch* was an abysmal failure, disliked and derided by the buyers and the public alike. It is a legend that dies hard, though there is absolutely no evidence for it; as we have seen, the painting was hung in places of honour, and no record survives of adverse criticism during Rembrandt's lifetime. Captain Frans Banning Cocq was certainly pleased with it, for he had a watercolour copy inserted in his personal album, with a proud inscription alongside it (but then he *was* the most prominent person in the scene). Some of the other guardsmen may have been reconciled to their insignificance by the financial arrangements, for it seems likely that they contributed to the cost according to their means, buying more or less prominent places in the picture; their costumes suggest that they were not all equally well-off, unlike officers, surgeons and similar groups who commissioned portraits.

If they understood the point of Rembrandt's innovations, they should have been flattered. For instead of making them full-fed clubmen, as Hals would have done, he turns them into heroes. Instead of a school photo, we are presented with a drama in which the guardsmen make ready to march out behind their intrepid leader; a banner is being raised, halberds aligned, the drum beaten; a scampering child, a dog snarling in alarm, a gun going off, all add to the atmosphere of excitement. These comfortable burghers of the civic guard might be setting out on a dangerous mission; their children may — and their grand-children probably will — believe it to have been so. As well as being a great work of art, *The Night Watch* is a highly original act of flattery. Appropriately enough, it marked the climax of Rembrandt's public success, which was soon to be followed by years of fading popularity, scandal, bankruptcy and sublime achievement.

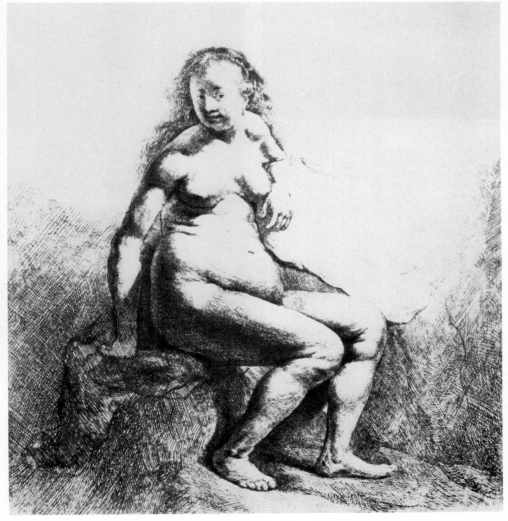

Right: *Nude Seated on a Mound. c.*1631. This etching is an example of Rembrandt in full reaction against the Renaissance cult of ideal beauty: its relish for grossness is quite often found in the popular art of the Low Countries. Bibliothèque Nationale, Paris.

45

The Middle Years

In the 1640s Rembrandt's paintings lost some of their popularity — not suddenly and catastrophically, as legend suggests, but gently and steadily, in a perfectly comprehensible way. In the 17th century, fashions in art came and went just as they do now, and artists were 'discovered' and 'forgotten' according to whether they did or did not conform to a given trend; only the most adaptable stood any chance of remaining high fashion throughout their working lives. On the other hand, being 'forgotten' was not necessarily a disaster for an artist who managed to retain the loyalty of a smaller public, as Rembrandt did; even when demand for his paintings was at its lowest, he was given commissions to paint the portraits of wealthy people, and he had an international reputation as an etcher which brought in substantial orders from abroad. Any financial difficulties he experienced must have been of his own making, and even so did not become intolerable until the mid-1650s. Still, both the princely House of Orange and the Dutch public began to cool towards his work. Prince Frederick Henry

Below: *Danaë*. 1636. Hermitage Museum, Leningrad.

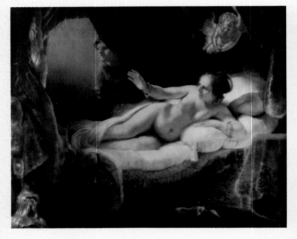

Right: *The Angel Leaving Tobias*. 1637. The moment at which the divine reveals itself was one of Rembrandt's favourite subjects. Here the angel takes its leave from Tobias after guiding him through a dangerous journey which has ended in the curing of his father Tobit's blindness. Musée du Louvre, Paris.

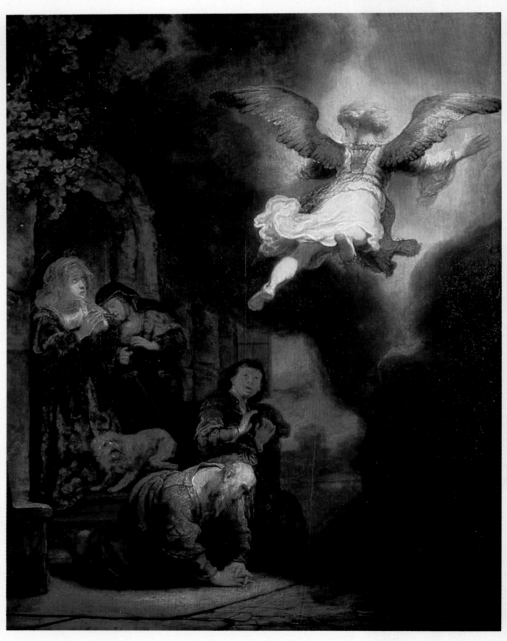

46

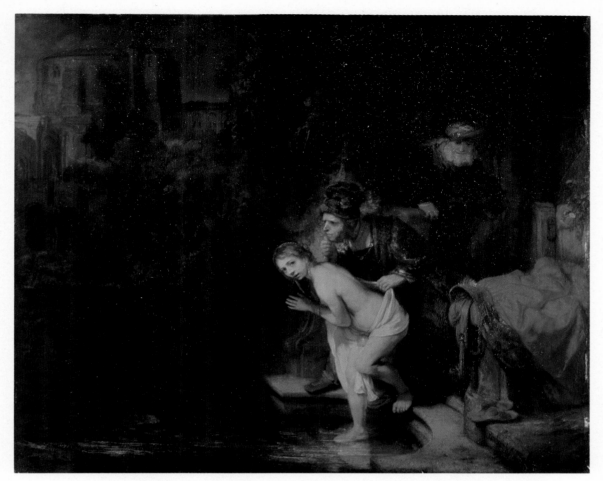

Susanna Surprised by the Elders. 1647. Oil on panel. The earliest reference to this picture is in an Amsterdam sale in 1738. Later in the century it was in the collection of Sir Joshua Reynolds. Gemäldegalerie, Berlin-Dahlem.

continued to buy Rembrandt's paintings through Huygens during the 1640s, but his death in 1647 severed Rembrandt's connection with the family; Huygens seems to have turned against him, and when the Prince's widow ordered decorations for her new country house, Rembrandt was not asked to contribute. From 1650 the House of Orange was in eclipse (Frederick Henry's successor died suddenly, leaving only a posthumously-born son to carry on the dynasty), and it did not recover its quasi-royal status during Rembrandt's lifetime. The mood of the general public also changed, partly influenced by the renown of the polished Flemish artist Anthony van Dyck, who had made a great success at the English court, and partly perhaps by the growing affluence and security of Dutch society. Elegant, carefully finished paintings were now in demand, and pupils of Rembrandt such as Govaert Flinck, Jacob Backer and Ferdinand Bol became rich and respected by giving the public what it wanted. Rembrandt either could not or would not. At a time when emphatic *chiaroscuro* was becoming unfashionable, he made it an increasingly important feature of his art. And at a time when outward elegance was admired, he was turning away from public art and dramatic scenes, infusing even the great biblical conflicts with a profound, reflective quality; this was reinforced by a subtle *chiaroscuro* that, instead of isolating and dramatizing the figures, brought them into harmony with their surroundings. On occasion, experts have been able to use X-rays to follow the development of Rembrandt's art within a single painting, for he sometimes worked on the same canvas intermittently for years. One example is the famous *Danaë*, in which a naked woman appears to be welcoming an unseen lover to her bed; the scene is probably based on the Greek myth concerning a well-guarded princess, Danaë, who was impregnated by Zeus, king of the gods, in the form of a shower of gold — which is, unfortunately, nowhere in evidence in Rembrandt's picture, so that complete agreement about the subject has never been reached. The painting itself was begun in 1636 and then re-worked in the mid-1640s or even later. Most of it is in Rembrandt's earlier manner, including the fettered cupid (whose presence as 'Love-in-Chains' suggests that the subject really is Danaë, whose father kept her away from men because it was prophesied that she would give birth to a son who would kill him); the woman herself has the kind of presence, or 'weight', and an unglamorized womanliness that Rembrandt only began to achieve in the 1640s. Similar changes can be traced from

47

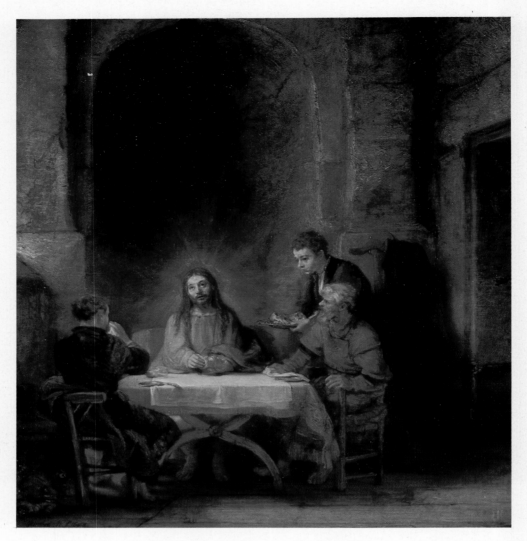

The Supper At Emmaus. 1648. The Risen Christ reveals himself to his disciples. Rembrandt went back to this subject again and again. Musée du Louvre, Paris.

picture to picture without a great deal of critical apparatus, especially where the subject remains the same; fortunately Rembrandt's preoccupation with certain biblical episodes (Susannah Surprised by the Elders, Tobias and the Angel, The Supper at Emmaus, and so on) makes it possible to observe quite clearly what can only be partly expressed in words.

Rembrandt's persistence in painting biblical scenes may have been another factor in his relative unpopularity; if anything, the already small Dutch market for religious art was shrinking. Hardly any of Rembrandt's biblical works seem to have been painted in response to definite commissions, and he must have kept many of them by him for years at a time. So, although it would be quite wrong to picture Rembrandt as a sort of 'avant-garde' artist, bent on outraging public opinion, he did largely ignore both the style and the content that should have been cultivated by any painter who hoped to make a really substantial income. Since there is no question of Rembrandt's ability to paint in the fashionable way, there is no escaping the conclusion that he chose not to — a remarkable, possibly unique exhibition of independence and inner-direction on the part of a 17th-century artist. The idea that he was an 'eccentric genius' — eccentric by the standards of the time — is confirmed by the stories his earliest biographers tell. He is said to have dressed carelessly, and to have habitually wiped his brushes on his smock. When he was at work he detested being interrupted, and would not have opened his door to even the greatest king in the world. And he hated people looking over his works in progress, and used to warn them off by telling them how unpleasant they would find the smell of the paint. Such anecdotes have a myth-making air about them when told of more recent artists, but they fit in well with everything else we know of Rembrandt's art and life.

In the 1640s Rembrandt seems to have been more interested in the New Testament than the Old, and the masterpieces of the period include such paintings as *The Adoration of the Shepherds, Christ and the Woman Taken in Adultery, The Holy Family,* and *The Supper at Emmaus.* It was probably during this period too that he etched *Christ Healing the Sick* — the famous 'Hundred Guilder Print', so called because Rembrandt is said to have bought back one of

48

Right: Drawing for *The Angel Ascending in the Flames of Manoah's Sacrifice* (below). Kupferstichkabinett, Berlin.

Below: *The Angel Ascending in the Flames of Manoah's Sacrifice.* Dated 1641 but probably executed later: part of the painting may be the work of a pupil. The departing angel has just announced that the couple will be the parents of Samson. Staatliche Kunstsammlungen Dresden, Gemäldegalerie Alte Meister.

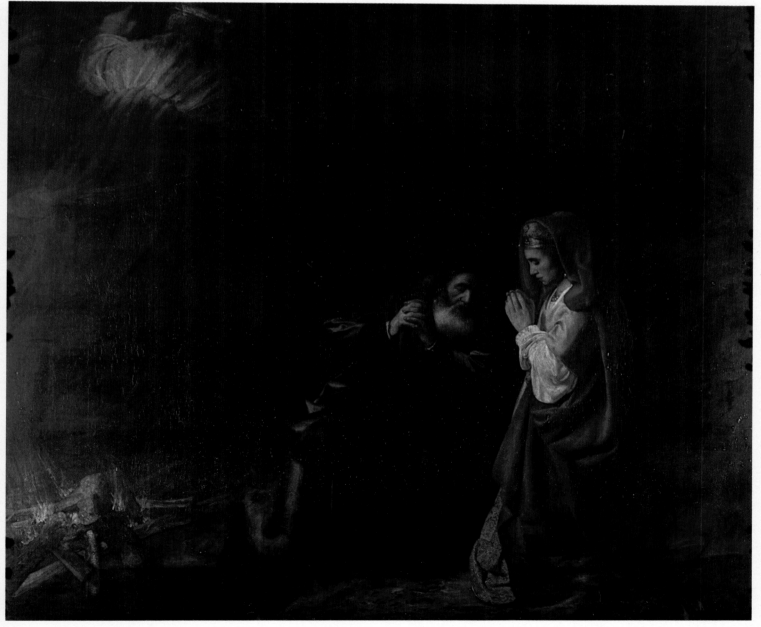

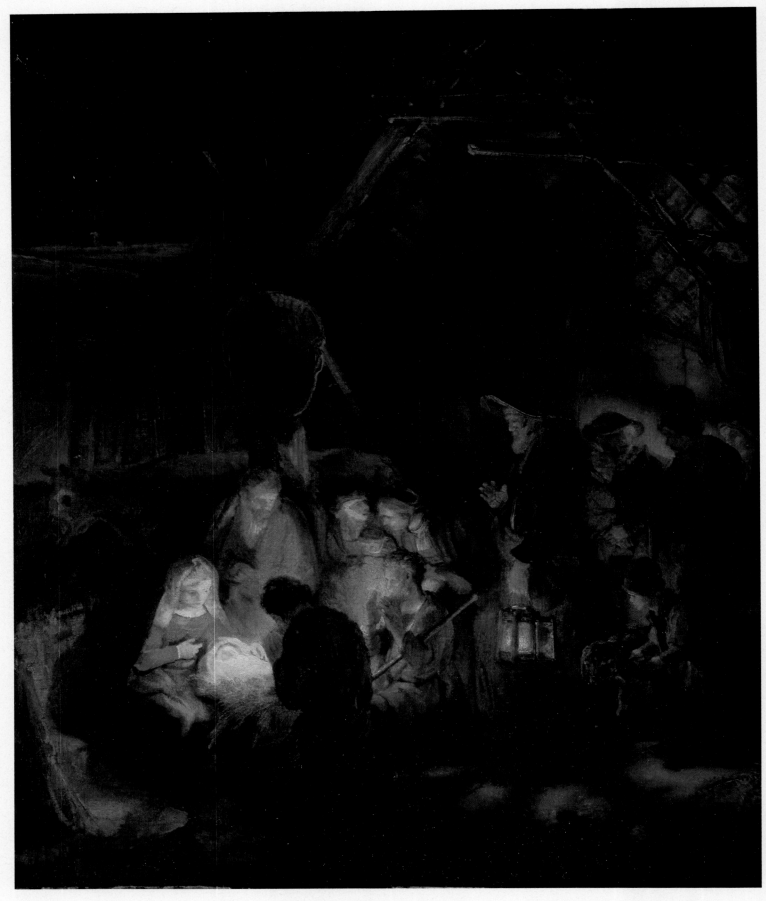

Above: *The Adoration of the Shepherds.*
1646. In treating this subject Rembrandt
represents ordinary men and women
transfigured by their contact with divinity.
National Gallery, London.

Right: *Christ and the Woman Taken in
Adultery.* 1644. National Gallery, London.

50

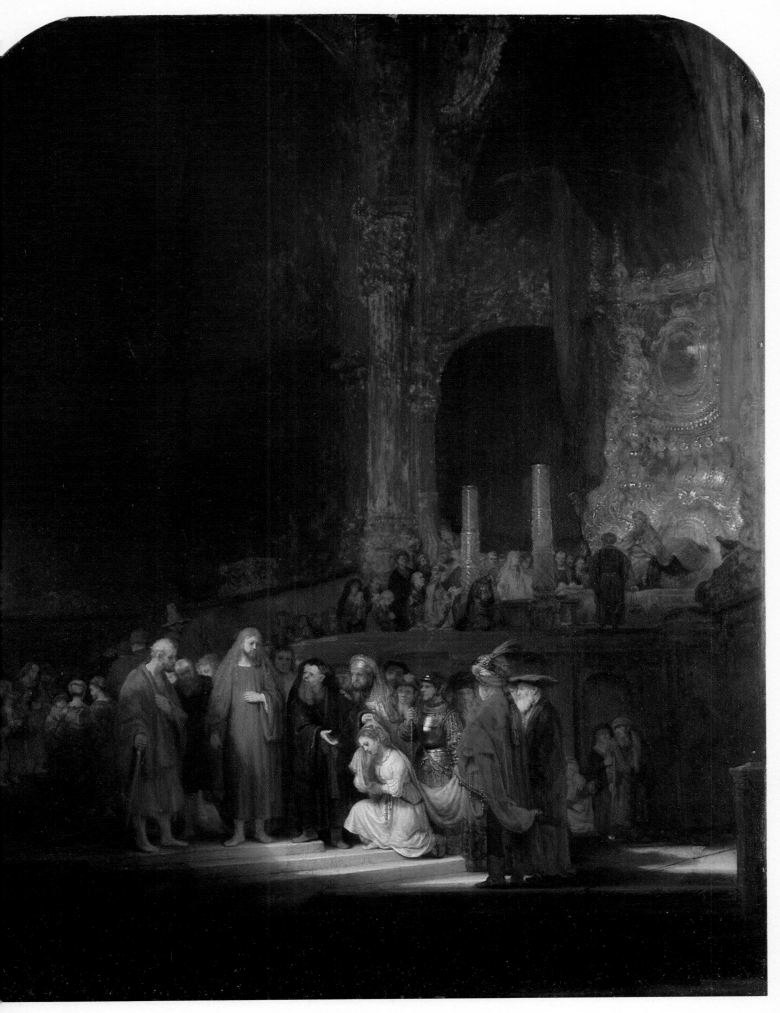

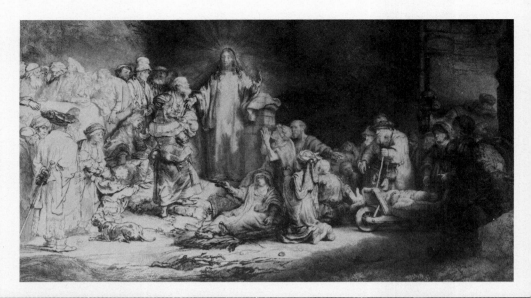

Right: *Christ Healing the Sick*. The most famous of all Rembrandt's etchings, often called 'The Hundred Guilder Print'. It dates from the early or mid-1640s. British Museum, London.

Below: *The Holy Family*. 1646. A pleasant piece of illusionism: the frame and the half-drawn curtain are not real objects but are part of the painting. Staatliche Kunstsammlungen Kassel, Gemäldegalerie.

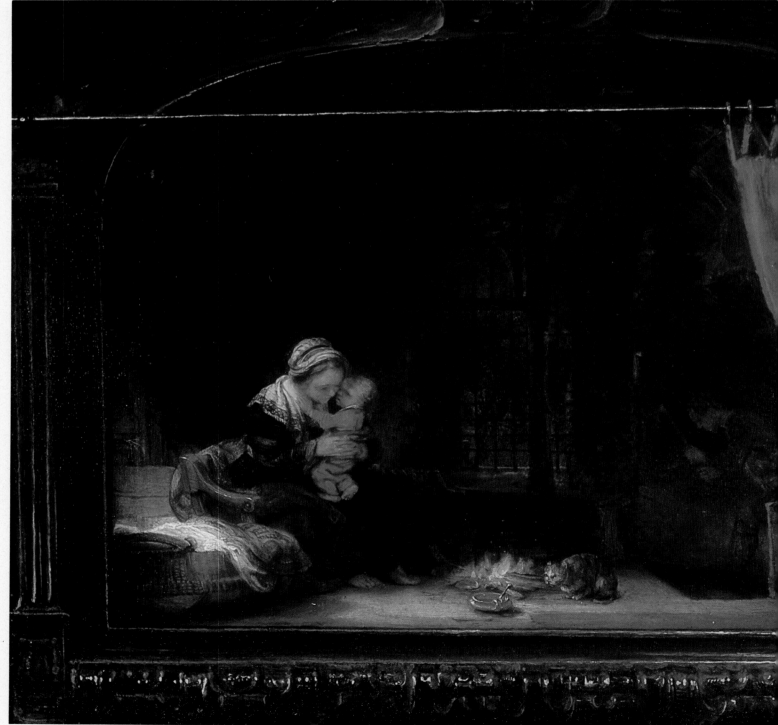

52

Right: Detail of the Virgin Mary from *The Holy Family with Angels.* 1645. Hermitage Museum, Leningrad.

Below right: Sheet of studies from the later 1630s, executed in pen and wash with red chalk. Barber Institute of Fine Arts, Birmingham University.

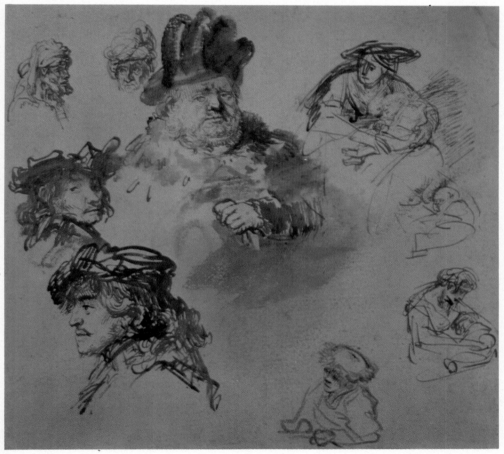

the prints at an auction for this very large sum. (One of his extravagances was to do this sort of thing with a view to keeping his prices up; but his commercial judgement appears to have been questionable.) *Christ Healing the Sick* is the most famous of all Rembrandt's etchings, dramatic in its use of *chiaroscuro*, with a radiant, taller-than-normal Jesus receiving children while surrounded by the sick (one of them prosaically laid out in a good Dutch wheelbarrow), who comprise a wonderful gallery of characters. The narrative situation is unusual in being a synthesis of various episodes instead of a straightforward account of a single event: as well as children and the sick, the print includes a group of Pharisees, the rich young man whom Jesus advised to give all that he owned to the poor, and a number of less direct allusions to biblical episodes.

By this time, Rembrandt did not confine himself to etching pure and simple, but extended his range of effects by working directly on the copper plate with

53

a burin and a dry-point 'pencil'. The burin, of course, introduced an element of engraving into the work. The hard steel dry-point pencil also cut into the metal, but its distinctive feature was to create a 'burr' — a furrow-ridge of metal that held the ink and gave a thick, attractively heavy line in the first few impressions taken from the plate (the burr was fairly quickly flattened out by the action of the press).

This mixing of techniques is one of the signs of a great master, in such complete command of his tools that he can dare any permutation in order to achieve the effects he seeks. The same freedom appears in Rembrandt's drawings, most characteristically in combinations involving pen and brush (though he also on occasion used chalks and crayons). He used a quill pen for some years, and then adopted the reed pen, which gave a stiffer line with an enhanced feeling of structural strength; the ink is generally bistre, a brownish fluid made from charred wood. Most of his drawing was done with a pen, with additional touches from the brush, which was otherwise used to apply broad areas of wash between the lines made by the pen. On occasion, however, the entire drawing was done with the brush, as in the wonderfully free and cursory *Woman Sleeping*, finished off with slashing curves suggestive of Oriental calligraphy. Rembrandt even used his fingertips as tools, brushing them into areas of the still-wet drawing to create shadowy atmospheric effects. By such means he executed drawings of an apparent spontaneity and a suggestive quality that were unlike anything done before. Modern taste, which admires the spontaneous and 'unfinished' in a way

Woman Reading.
Sepia drawing.
Musée Bonnat,
Bayonne.

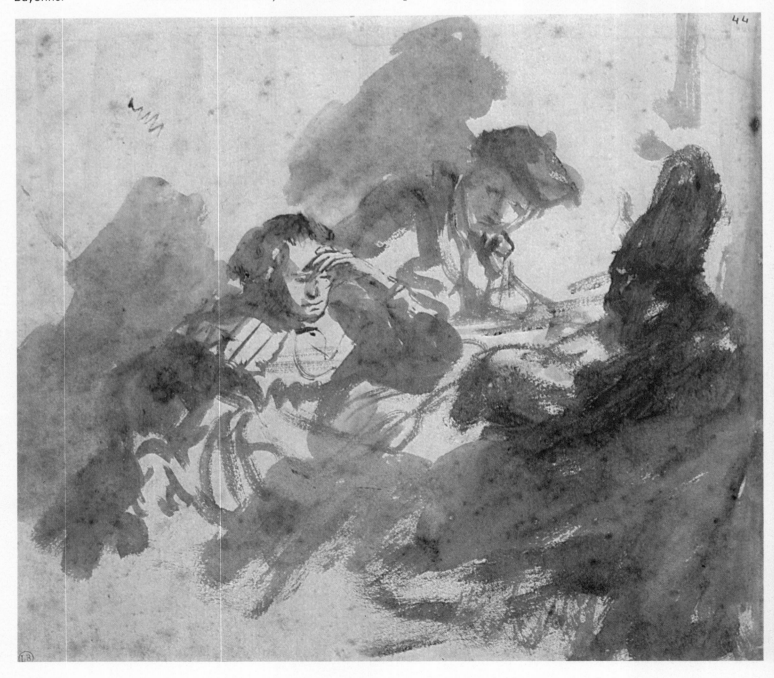

54

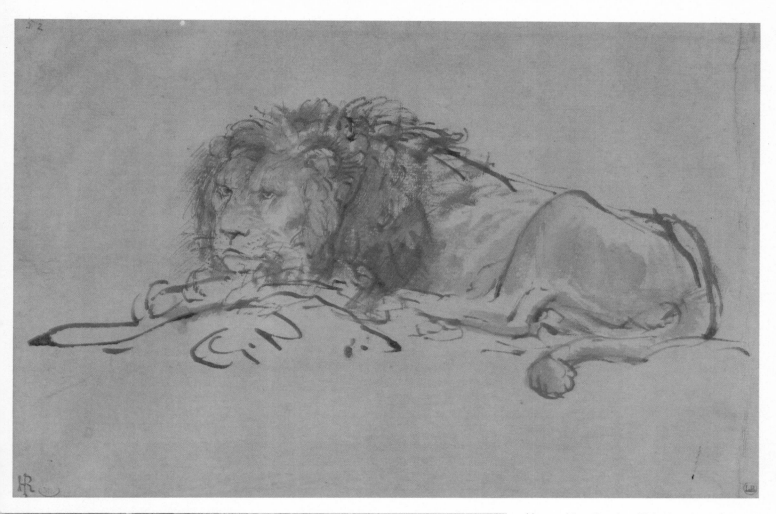

Above: *Lion Resting.* This drawing of *c.*1651 is one of many studies of animals and exotic birds (lions, elephants, birds of paradise) done by Rembrandt. Musée du Louvre, Paris.

Left: *Man Praying at a Sickbed.* Musée Bonnat, Bayonne.

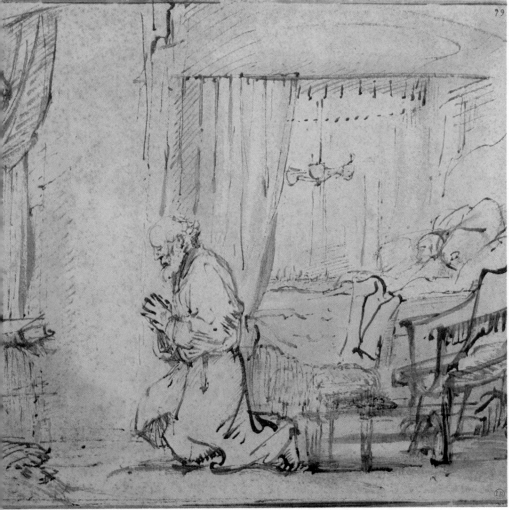

that the 17th century would have found incomprehensible, is inclined to prefer Rembrandt's drawings to his etchings; and there are some who would even put them above his paintings. His complete mastery of the medium is implied in a simple rule acknowledged by all experts: if a drawing of disputed authorship shows any signs of preparatory work such as pencilled guide-lines, it is not by Rembrandt, who never felt the need of them.

During the 1640s he found a new subject for his drawings and etchings in the countryside around Amsterdam. He had painted a number of landscapes in the 1630s, and was to paint a few more later on in a broader, more confident style; but both groups are notably imaginative and un-Dutch, with a romantic, often stormy, atmosphere and picturesque details such as ruins, castles, woods, mountains and ravines. As a painter he showed no great interest in the realities of the Dutch landscape, and must have taken his inspiration from prints and paintings of foreign lands. By contrast, almost all the drawings and etchings are straightforward, truthful accounts of anything that was to be seen on river- or canal-side walks — town views, locks, boats, farms, cottages, windmills, labourers, churches, distant spires. We must suppose that in the 1640s Rembrandt acquired the habit of walking out most days — it can only have taken ten minutes or so to leave the city behind — for, once started, he sketched the local landscape until the end of his life.

The impression of ever-growing depth and maturity that we receive from Rembrandt's works is rather contradicted by some scandalous documents that have survived from the period 1649–56. Some time after Saskia's death in 1642, Rembrandt employed a young widow named Geertge Dircx to look after Titus; in November 1642 he put up 1,200 guilders towards the ransom of a ship's carpenter — probably Geertge's brother — from the Barbary pirates, so he and Geertge must already have become intimate. Then, in September 1649, we find her bringing a suit for breach of promise against him; shortly before this, he had agreed to pension her off with 60 guilders a year, and he now increased his offer to 160. The matter nonetheless went to court, where Rembrandt denied that he had ever promised to marry Geertge, or that they had had any long-standing sexual relationship — though he must have been aware that his earlier attempts to buy her off made his statements hard to credit. The court evidently disbelieved him, but merely increased his yearly obligation to 200 guilders, perhaps on the fellow-feeling principle that masters' sins against servants were best not penalized too harshly. Thus far, there are two additional points of interest. One is an affidavit describing the original agreement-to-part between Geertge Dircx and Rembrandt, including the 60-guilders-a-year arrangement; the affidavit was sworn by Hendrickje Stoffels, another servant in the house, who was to be Rembrandt's mistress and housekeeper until her death in 1663. It is likely (to say the least) that Rembrandt had already transferred his affections to her, and that terrible jealousies, rages and intrigues underlie the unemotional records concerned almost exclusively with money and property. However, money and property also played a part in this domestic drama. Each agreement between Rembrandt and Geertge was conditional on her not changing a will she had

View on the Amstel. This pen and brush drawing is one of many views of the countryside around Amsterdam that Rembrandt made from the 1640s. Devonshire Collection, Chatsworth, Derbyshire.

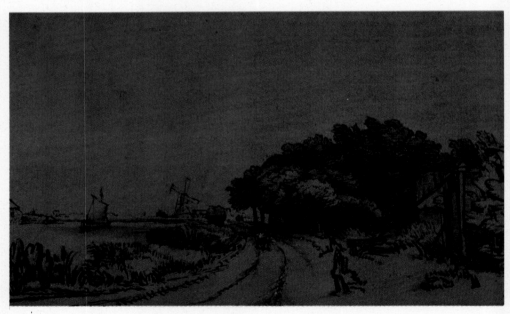

made in 1648, leaving most of her possessions to young Titus van Rijn; and the marriage commissioners' court order also included this stipulation. The obvious inference is that Geertge owned heirlooms of the van Rijn family which Rembrandt had been rash enough to give her — probably, since Titus was to be the beneficiary, Saskia's jewellery. The stipulations about Geertge's will were intended to prevent her from disposing of the jewellery, which (according to Hendrickje Stoffels) she had pawned even before leaving Rembrandt's house.

The next we hear of Geertge Dircx is in July 1650, when a complaint was laid against her by some of her neighbours, who objected to her immoral, irregular life and questioned her sanity. As a result, she was committed for a twelve-year term to an institution at Gouda. This was a cross between a workhouse and a rehabilitation centre, taking in unemployables, the sub-normal, prostitutes, alcoholics and others who would not conform or could not cope; they were looked after, set to work and sermonized, after the fashion of the time. Rembrandt laid out the committal expenses on behalf of Geertge's family, a gesture that can be seen either as the final move in a plot to keep his ex-mistress under lock and key, or as a disinterestedly helpful act. This last interpretation seems less likely when we find out that, five years later, Rembrandt was consulted over the possibility of Geertge's release (which makes it look as though he had been

57

the moving force behind the original committal), and that he vehemently opposed it. Geertge was released all the same, and in 1656 appeared on the list of his unpaid creditors (for her 200 guilders a year) before disappearing altogether from the surviving records. Rembrandt, meanwhile, was applying to have Geertge's brother thrown into debtors' prison for non-payment (or rather non-repayment) of the committal expenses of 1650; but the proceedings seem to have fizzled out when Rembrandt became bankrupt.

This whole long and painful episode is impossible to evaluate properly from the existing documents, which give us a purely external view of matters that may have seemed very different from inside. Those who see Rembrandt's art as a direct expression of his life and character will prefer to believe him more sinned against than sinning — relentlessly persecuted by an hysterical, unstable woman who finally had to be put under restraint for her own good. That may in fact be the central truth of the situation, but...some of the details are all-too-obviously suggestive of enduring spite, of a master using law and privilege to bear down hard on a servant — at the very least, of an unattractive lack of magnanimity on Rembrandt's part. Which only goes to show that art and life are rarely correlated in a simple and satisfactory fashion.

For that very reason, we should not read too much into the change in Rembrandt that can be seen in the self-portraits from about this time. He aged rapidly; or perhaps it would be better to say that he suddenly began to show his age, a perfectly natural occurrence that need not have been attributable to his troubles with Geertge or any other external cause. However, the change does go deeper than straightforward ageing. In the great painted self-portrait of 1640, he is opulent and almost sleek in his wide, stylish hat, rich fur-trimmed jacket, and embroidered and pleated shirt; here and elsewhere, his continuing delight in dressing up is obvious. By contrast, a superb etching of 1648 shows him drawing beside a window in workaday clothes and with a plain workaday expression on his furrowed and worn face. Later self-portraits, fallen-fleshed, show a startling intensification of gravity and sorrow, appealing with a new directness to the viewer (or to Rembrandt himself, gazing out from a mirror or painted surface). And the old taste for finery has largely disappeared, although in the 1658 self-portrait (Frick Collection, New York) his costume and enthroned posture are deliberately kingly; his expression, however, is that of a ruined, disillusioned, exiled monarch — but then by this time he had experienced actual ruin and must have been contemplating an imminent departure from his grand house on the Breestraat.

These preoccupations are not apparent in his other works of the early 1650s, when he was producing one masterpiece after another. The paintings are marvellously rich in colour and human feeling. They are also extremely varied in subject-matter: *Aristotle Contemplating the Bust of Homer*, *Bathsheba*, *The Polish*

Landscape with a Windmill. Pen and bistre drawing. Musée Condé, Chantilly.

58

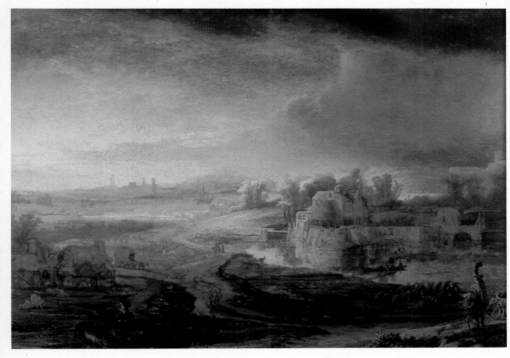

Left: *Landscape with a Castle by a River.* c.1640. Wallace Collection, London.

Rider, Portrait of Jan Six, The Slaughtered Ox, The Anatomy Lesson of Dr. Deyman, Jacob Blessing the Sons of Joseph. To modern eyes, the classical context of the *Aristotle* (1653, Metropolitan Museum of Art, New York), seems irrelevant. The ancient Greek philosopher, opulently and anachronistically costumed, rests one hand on the bald pate of Homer and gazes in melancholy at the bust; but the design and colour and brushwork, and the reflections on time and vanity that the picture suggests, are, we feel, what the painting is 'about', irrespective of the identity of the man or the bust. This was not true for 17th-century man, and evidently not true for Rembrandt, who actually chose the subject when asked for a 'philosopher' by his client, one Antonio Ruffo of Messina in far-away Sicily. Some years later Rembrandt painted Ruffo two companion-pieces for the *Aristotle*, a *Homer* and an *Alexander the Great*, thus confirming that the specific titles did have some meaning for him (the connection seems to be that the epic poet Homer was interpreted by the philosopher-critic Aristotle, who was also the tutor of Alexander, the man of epic deeds). Until a couple of centuries ago, 'the ancients' were regarded as the superiors of European man, giving him a pattern that he should try to follow in almost all things; and the mere inclusion of Greek and Roman names in the title of a painting gave it an extra dimension of meaning that even the enthusiastic classicist of the present day finds difficult to appreciate.

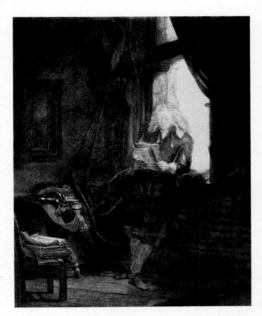

Above: *Jan Six.* 1647. This etching shows Rembrandt's friend – probably at his own wish in his role as poet, surrounded by the evidence of his culture and taste. However, we know that he was also an ambitious and hard-headed public figure who seems to have dropped Rembrandt after his bankruptcy. Fitzwilliam Museum, Cambridge.

The subject of *The Polish Rider* (Frick Collection, New York) is much more mysterious. This deeply romantic painting, with its rich colours and superb surface texture, shows a handsome young warrior in East European costume, with a fur hat and a long caftan-like coat; he is armed to the teeth and mounted on a small, distinctly ill-looking horse. (Rembrandt's painting of it has been defended so vociferously by critics that the ordinary viewer *almost* comes to disbelieve his eyes, which tell him that this nag is anatomically unconvincing as well as unpleasing to contemplate.) Despite his weaponry, the young man's face has a still, rapt quality that is characteristic of Rembrandt's art, though neither this nor his statuesque pose could have been easy to maintain on a moving horse. Rembrandt painted only one other equestrian portrait — also none too convincing — and it seems likely that the man on horseback, traditionally an expression of power and pride since Roman times, was too out of key with his own mood to be an appealing subject. The origin and intention of *The Polish Rider* remain a mystery; we cannot even be sure that he is a Pole rather than, say, a Hungarian, although there are one or two suggestive links between Rembrandt and Poland that will be examined later on.

The Slaughtered Ox (1655) is at the opposite pole from the romanticism of *The Polish Rider*. This headless, flayed carcass, hanging by its stumps from a beam, might almost be an ironic comment on the conventional Dutch still-life, with its decorous dead fish or game birds gracing a display of kitchenware or a sideboard. It is more likely, however, that Rembrandt painted it just because

59

he had no preconceptions about what a work of art should be, and recognized the painterly possibilities of a huge lump of ruptured flesh. Behind the carcass, a woman peers out from a doorway. Humanity is rarely far away in Rembrandt's work, and indeed there is not a single true still-life in all 600 of his surviving paintings.

He continued to produce many portraits, both of wealthy patrons to whom we can give a name, and of unknown men and women whom he may have painted for no better reason than that he wanted to. In the 1640s the portraits were often a little stiff and official, and quite highly finished, like their subjects — men and women in rather prim, contained-looking poses, dressed in black with large, elaborate ruffs or lacy collars. The portraits of the 1650s reflect a change in the fashions and mood of Dutch society, but also a development in Rembrandt's art; his sitters are more casual in dress and posture, as in the romantic 'cavalier' portrait of *Nicolaes Bruyningh* (1652), and the difference is emphasized by the far greater freedom with which they are painted. Perhaps the finest of all is the *Portrait of Jan Six* (1654), whole areas of which are executed with vigorous brushstrokes of audacious visibility. In particular, the eye is drawn to Six's hands; he is pulling on a glove, and the forceful strokes of the brush create a slight blurring that suggests movement, as in a photograph. Six's clothes are also painted in this cursory, vibrant style, which points up the withdrawn quality of his face; the red cloak, grey coat, fine linen and long gloves belong to the man of business and public affairs — in the painting they *are* the man of business and public affairs, all stir and assertion — whereas the face has for the moment transferred its allegiance to another level of being, concerned with more profound questions. In this instance the sitter may have encouraged Rembrandt to show something of his inner nature, for Six himself wrote of the painting in his commonplace book, 'Such a face had I, Jan Six, who since childhood have worshipped the Muses.' He was in fact a poet (or, at any rate, wrote verse), and published a drama, *Medea*, for which Rembrandt provided a frontispiece; Rembrandt evidently omitted to read the play, since his etching represents an episode in the mythical story of Medea and Jason that does not appear in Six's version!

Rembrandt and Six were on sufficiently intimate terms for the artist to execute some sketches in Six's 'Album of Friends' in 1652, two years before the portrait was painted. Rembrandt also stayed at Ijmond, Six's house in the country, and several of his drawings are said to have been done there. He also etched *Six's Bridge*, which is the subject of an entertaining story told to illustrate the speed and assurance with which Rembrandt worked. When about to dine at Ijmond, Six discovered that there was no mustard in the house, and sent one of his servants to buy some at a nearby village. Rembrandt bet him that he would be able to finish an etching before the servant returned, and he won his bet with *Six's Bridge*. The story is all the more convincing in that the etching has a sketchy, spontaneous quality that is quite unlike Rembrandt's other works in the medium, which are notable for their density and high finish. A good example of this is an etching of Six himself, leaning on a windowsill reading, very much the gentleman-scholar; the feeling of spontaneity is absent, appearing instead

Below: *Portrait of Nicolaas Bruyningh.* 1652. An example of the warmer portrait manner of Rembrandt in the 1650s. Staatliche Kunstsammlungen Kassel, Gemäldegalerie.

Right: *Six's Bridge.* 1645. Rembrandt is said to have executed this etching after betting his host, Jan Six, that he could finish it before Six's servant returned from the nearest village with mustard for their lunch. British Museum, London.

60

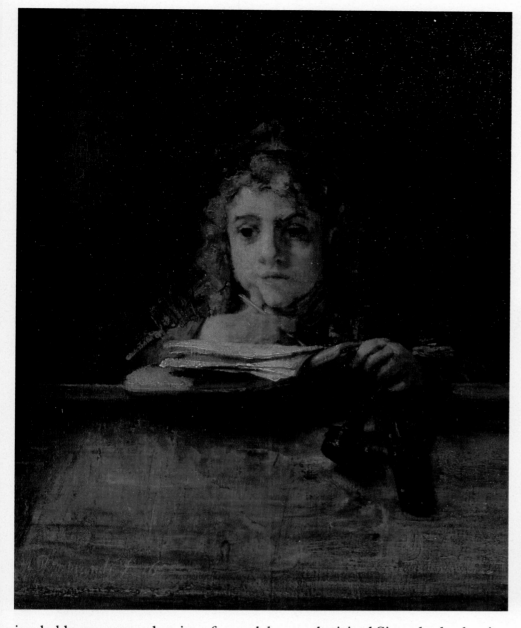

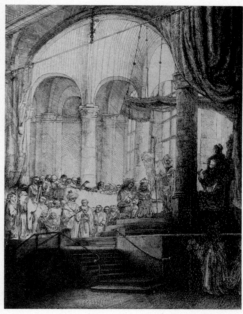

Left: *Titus*. 1656. Rembrandt painted and drew his son Titus on many occasions and at various ages. Here he is still the small boy, pensive over his school work. Boymans-van Beuningen Museum, Rotterdam.

Above: *Medea* or *The Marriage of Jason and Creusa*. This etching was used as the frontispiece for *Medea*, a play based on Greek myth by Rembrandt's friend Jan Six. British Museum, London.

in a bold preparatory drawing of a much less aestheticized Six and a dog leaping up at him.

Jan Six was a wealthy man; he had inherited a prosperous textile business, but retired early to devote himself to the arts and civic affairs. However, he remained hard-headed. When Rembrandt was desperately raising funds in 1653, Six lent him 1,000 guilders after insisting that Rembrandt find a third party who would agree to guarantee repayment of the loan; as a result, Rembrandt's later bankruptcy cost the third party, not Six, the 1,000 guilders. Six went on to make a successful career in public life, eventually becoming a burgomaster of Amsterdam. After 1656 he disappears from Rembrandt's life, and it is assumed that he dropped the painter because of the disgrace of his bankruptcy.

The persons closest to Rembrandt in both his life and his art were his son Titus and Hendrickje Stoffels. He painted both many times. As a boy in his teens, Titus is depicted rather sentimentally in such famous paintings as the portrait of 1655, where he sits pensively, thumb on chin, over his schoolbooks, and in *Titus Reading*. Hendrickje Stoffels, who remained Rembrandt's companion until the end of her life, was (as we shall see) trusted completely by him, and bore him a child; it seems likely that Rembrandt would have made her his wife but for the clause in Saskia's will that penalized remarriage. Not one of his paintings is a documented portrait of Hendrickje, but one woman's face appears so often over the years that it is impossible to conclude that she is anyone but Rembrandt's housekeeper, mistress and chief model. All other considerations apart, if this were *not* Hendrickje it would mean that Rembrandt, who used himself and all his familiars as free models, chose to leave no certain record of

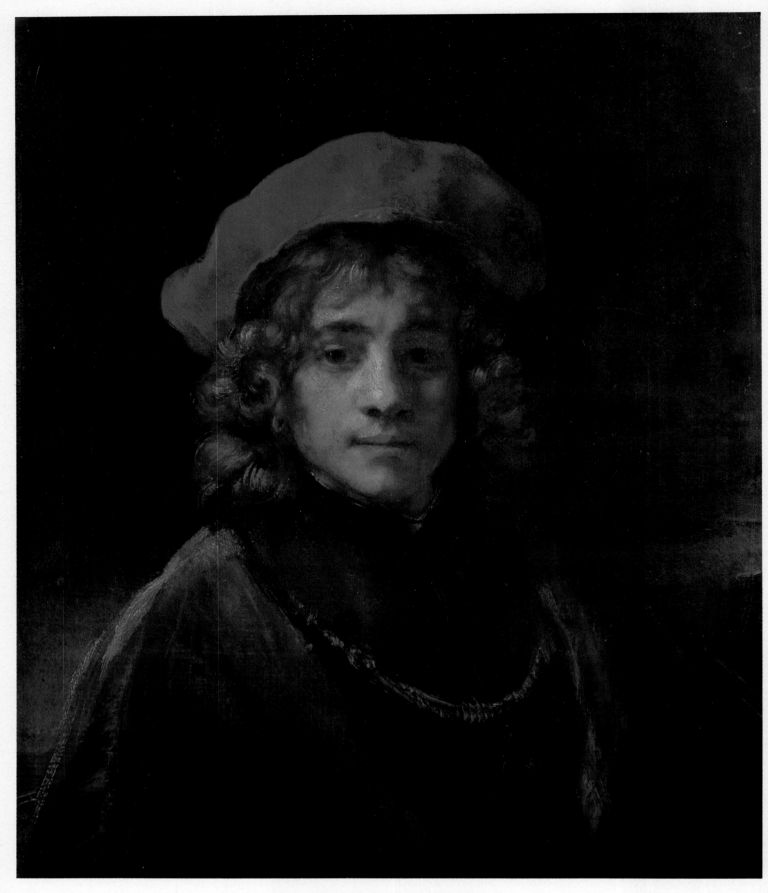

Titus. c. 1658. A portrait of Rembrandt's son, already far more mature-looking than in the portrait painted a year earlier. Wallace Collection, London.

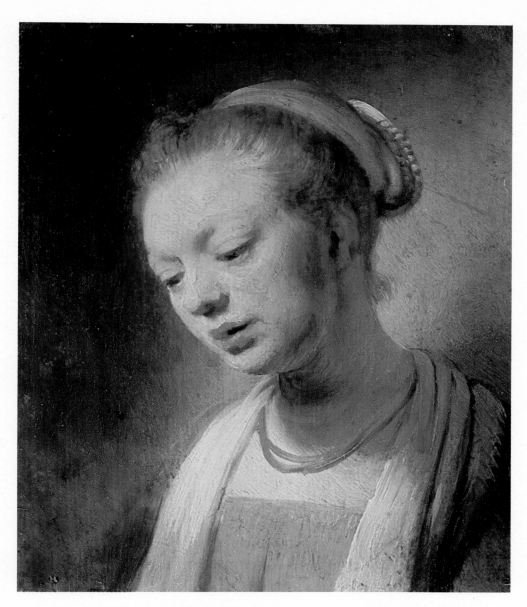

Portrait of a Young Girl. Mauritshuis, The Hague.

a woman who shared his life for at least fourteen years. Writers on Rembrandt are inclined to indulge in under-documented inferences about his life and relationships; but in Hendrickje's case many of the inferences seem quite compelling. She is the girl with a broad, concave face, a high forehead, a full mouth and a slight double chin; a girl notably less bejewelled than Saskia, though she appears once, still very young, in a fur wrap. She is probably the *Woman Bathing* (National Gallery, London) and certainly *Flora* (Metropolitan Museum of Art, New York). And 'Flora' is visibly the same woman as the chief figure in one of Rembrandt's greatest paintings, the *Bathsheba* of 1654. It was inspired by the Old Testament account of how King David saw a woman bathing, found out that she was Bathsheba, wife of Uriah the Hittite, committed adultery with her, and then arranged for her husband to be killed in battle. The Book of Samuel says only that 'David sent messengers and took her; and she came to him, and he lay with her'. But Rembrandt has softened the patriarchal brutality of the story; Bathsheba's summons has come in the form of a note (a love-letter?), which the naked Bathsheba holds, and ponders, while a servant dries her feet. She is lost in thought, but we can only guess at the nature of her reflections; sorrow and resignation are more apparent than pleasure. (Perhaps Rembrandt understood from the Bible narrative that the female subjects of kings — like the servants in Rembrandt's own household — had little control over the destinies that determined whether they should be wives or concubines.) Bathsheba's body is wonderfully solid and rounded, and yet her face dominates the picture and gives it its mood; she is the most *touching* nude in the history of art. And such is the magic of his brush that Rembrandt makes us find her beautiful although we can see that she is not really so.

The sins of the flesh and their consequences may well have been on Rembrandt's mind while he was painting *Bathsheba*. In that very year Hendrickje

gave birth to a daughter, Cornelia, who was her first surviving child by Rembrandt (an earlier baby had died). While Hendrickje was pregnant (and possibly because her pregnancy constituted unmistakable evidence of sin), she and Rembrandt were summoned to appear before the local council of the Reformed Church, charged with living in 'whoredom'. When they ignored the summons, two more were issued, for some reason naming Hendrickje alone, and eventually she appeared before the Church court and confessed to having engaged in fornication with Rembrandt. She was rebuked, told to repent, and forbidden to take part in the Lord's Supper; and there the matter seems to have ended. Cornelia was baptized into the Reformed Church. Hendrickje presumably remained intimate with Rembrandt, but as there were no more children (and therefore no more public evidence of sin) the Church was probably content to investigate no further. In a big city it must have been difficult to carry out the Church's traditional function of regulating morals, especially once a multiplicity of persuasions was tolerated; after all, both the seeker after truth and the unrepentant sinner were free to change their denominations if they were not satisfied with them.

Did Rembrandt do so? One theory put forward to explain the absence of summonses and rebukes directed at him by the Reformed Church is that he had simply ceased to be a member. This is lent additional plausibility by Baldinucci's statement that Rembrandt was a Mennonite. The Mennonites were an Anabaptist sect in many respects like the Society of Friends (Quakers); they did

Right: *Woman Bathing*. 1654/5. The woman in this affectionately painted work is probably Hendrickje Stoffels. National Gallery, London.

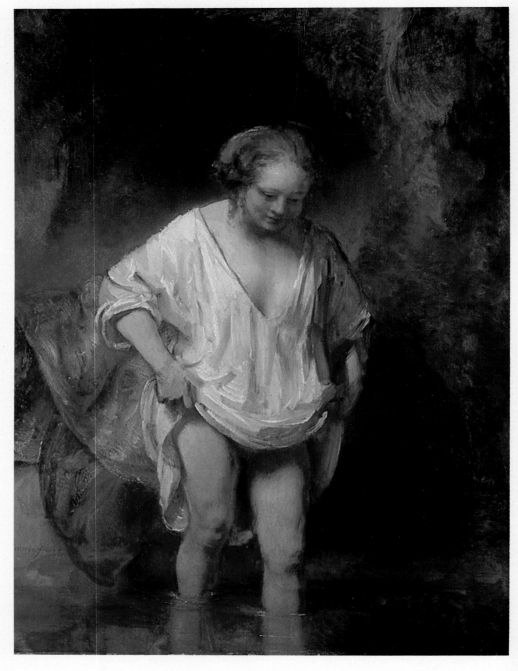

Right: *Woman in Bed*. In this painting of the late 1640s, the woman is generally identified as Hendrickje Stoffels, though the resemblance to other paintings of Rembrandt's mistress is not strong. Lord Clark has suggested that the woman may be Geertge Dircx, Rembrandt's previous mistress. National Gallery of Scotland, Edinburgh.

64

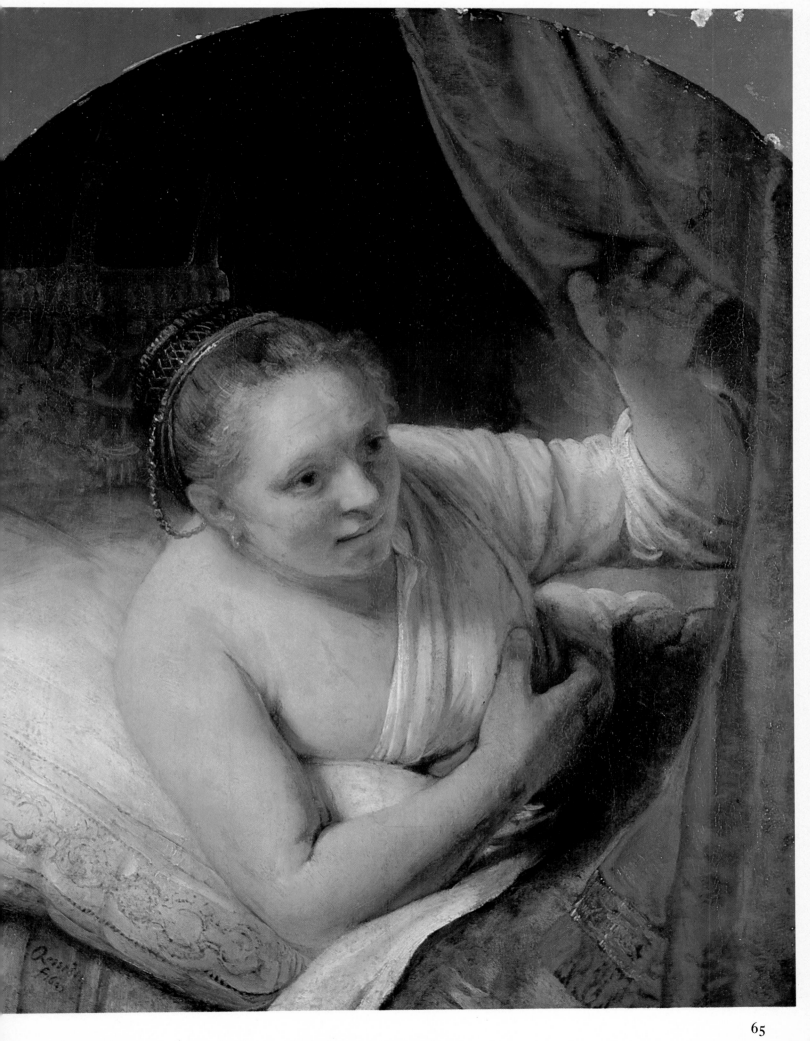

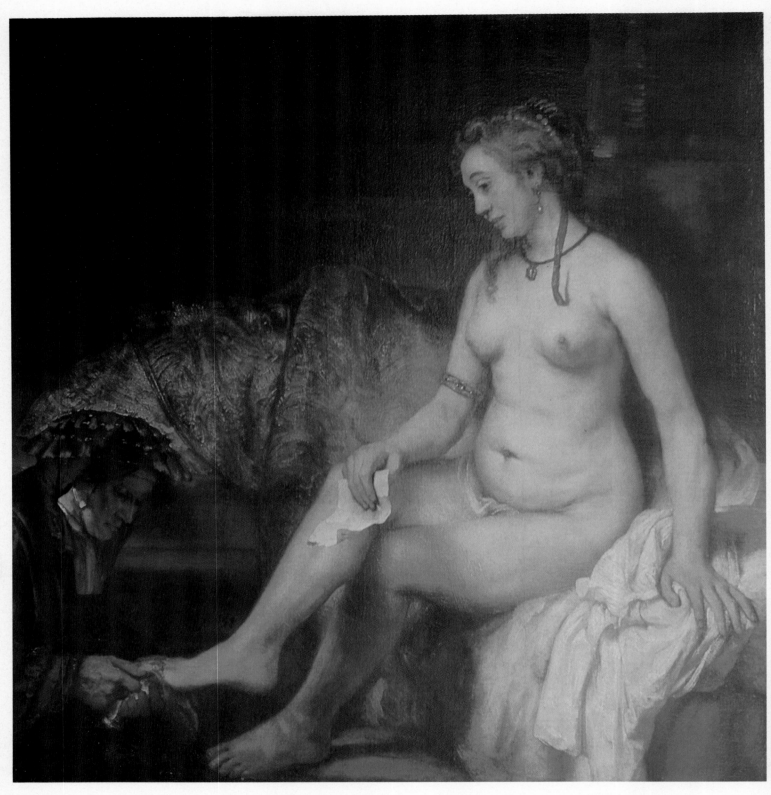

Bathsheba with King David's Letter. 1654. One of Rembrandt's loveliest paintings of Hendrickje Stoffels. Bathsheba, summoned to King David's bed, ponders her destiny. Musée du Louvre, Paris.

not bear arms or take oaths, and they prayed in silence at simple congregationalist services conducted without officiating ministers. Rembrandt certainly knew many of them, for although Saskia had been a member of the Reformed Church, Hendrik van Uylenburgh's side of the family were Mennonites and so were many of his clients and shareholders; Rembrandt himself painted and etched portraits of the celebrated Mennonite preacher Cornelis Anslo. Even Rembrandt's art apparently speaks in favour of the connection, for its quiet biblical spirit seems closer to Mennonite attitudes than to the more doctrinally rigorous and militant Calvinist outlook of the Reformed Church. But there are two objections to this impressive mixture of circumstantial evidence and reported knowledge: Rembrandt does not appear in the records of the Mennonite church, whereas he was not only baptized and married but also buried by the Reformed Church. If he was not a Mennonite, the way in which the Reformed Church discriminated between him and Hendrickje becomes inexplicable, and his exact

religious outlook unknowable; but there is no help for it. It is not beyond human wit to resolve the apparent contradictions in Rembrandt's life, but the resolutions are purely speculative and more fit for the novelist than the biographer.

The novelist might also do much with some odds and ends of information about 'the Polish connection', which is worth a few lines because of its intriguing aspects rather than for any discernible significance it may possess. We have already given some attention to the mysterious painting known as *The Polish Rider*, which has generally been dated to the 1650s. Can it be just a coincidence that a pamphlet of 1654 was published in Amsterdam under the *nom de plume* 'Eques Polonus' — the Polish Rider? The author argued in favour of complete religious toleration, which was of course desired by Mennonites, Catholics, Jews and other groups who, though they had remarkably little trouble with the authorities, would have preferred an assured legal tolerance and equality of treatment with the Reformed Church. The pamphlet may well have been written by a Socinian, whose sect had particularly strong links with Poland. The Socinians held views that can roughly be described as Unitarian, repudiating the divinity of Christ and most other specifically Christian dogmas in favour of belief in one God and in following the example of Jesus as a guide to right action — ideas that seemed utterly outrageous to 17th-century Christians of all persuasions. The founder of the sect had been Faustus Socinus (or, de-Latinized, Fausto Paolo Sozzini), an Italian who spent the last twenty-five years of his life in southern Poland, where Socinian and similar doctrines had gained a foothold. So the trail — if it *is* a trail — leads back to religious dissent in one of its more extreme forms. The link between the Socinians and Rembrandt would be firmer if his etching, generally known as *Dr. Faustus*, could be proved to have been done for them, as some authorities assert; but its meaning remains a matter of controversy. However, there is a final connection: Hendrik van Uylenburgh's father, the Mennonite, had worked in Poland, and Hendrik himself had been born in Cracow, the chief town in southern Poland. Whether any of this amounts to anything (or whether it is no more than a set of coincidences, explicable in terms of the numbers of foreign refugees in tolerant Holland) is never likely to be known — except to the novelist . . .

The Jews of Amsterdam exercised a more certain, if also more restricted, influence on Rembrandt. During the years in which he lived in the Breestraat, the street and the surrounding area became virtually a Jewish quarter. One of the leaders of the community, Manasseh ben Israel, lived almost opposite, and Rembrandt made a fine, flattering portrait etching of him; he looks every inch a prosperous Dutchman in his broad-brimmed hat and wide collar, but he was a formidable multi-lingual scholar, deeply pious, and a visionary who looked forward to the imminent arrival of the Messiah. (Such a combination was of course less uncommon in the 17th than in the 20th century.) One of Manasseh ben Israel's more bizarre endeavours was a little book called *The Glorious Stone*, which made Nebuchadnezzar's dream in the Book of Daniel the basis for Messianic prophecy; and Rembrandt made four etchings to illustrate the first edition. He also painted a number of commissioned portraits of Jews, which inevitably meant wealthy Sephardic Jews from Portugal and Spain, as unexotic

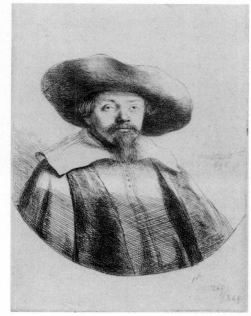

Below: *Samuel Manasseh ben Israel.* 1636. Rembrandt's etched portrait of his neighbour, one of the leaders of the Jewish community in Amsterdam. British Museum, London.

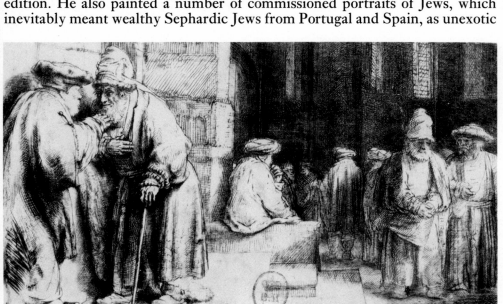

Left: *Jews in the Synagogue.* In this etching the Jews are poor and foreign-looking, in strong contrast to the wealthier members of the community of whom Rembrandt has also left a record. Bibliothèque Nationale, Paris.

67

Belshazzar's Feast. A painting from the 1630s entertainingly 'Orientalized', of the Babylonian king confronted with 'the writing on the wall'. The prophet Daniel told him it meant that the days of his kingdom were numbered. National Gallery, London.

as Manasseh in their appearance; but in addition he seems to have made his own private sketches, etchings and paintings of various Jewish types, including the poor East Europeans (the Ashkenazim), bundled up in their long, shabby caftans and wearing tall, shapeless hats or flattened turbans. If Rembrandt had Jewish friends and discussed religion with them, as we surmise, his contemporaries would not have regarded him as particularly eccentric, for the specifically Protestant interest in the Bible had developed into a fairly widespread interest in the language of the Old Testament and the 'people of the Book'; in the 1650s a similar interest prompted the English Puritan régime of Oliver Cromwell to admit Jewish immigrants after a period of exclusion that had lasted for over 350 years. (Rembrandt's patron Manasseh ben Israel was largely instrumental in securing this.) Jewish contacts may have been partly responsible for the greater attention paid by Rembrandt to Old Testament subjects in the 1650s, and they certainly influenced his treatment of biblical episodes. He quite often (though by no means consistently) used the Jews of Amsterdam as models for biblical characters; whether or not they were ethnically identical with the ancient Hebrews, they stimulated Rembrandt to show the men and women of the Bible as worn and rugged members of an alien patriarchal society rather than as thinly disguised Dutchmen. He also generally attempted to make his versions of Jesus look like a Jew, instead of the handsome Europeanized figure that had become the artistic convention. All this is symptomatic of the earnestness with which he undertook his religious paintings, and it goes far towards explaining how he avoided the empty theatricality of so much 17th-century religious art.

The impression of quiet intensity left by Rembrandt's work of the 1650s forms a stark contrast to the documented facts of his life, which were to culminate in his ruin.

68

Adversity and Achievement

The largest single factor in Rembrandt's financial troubles was the house on the Breestraat. In 1653 he still owed more than 8,000 guilders on it, representing part of the unpaid purchase price of 1639, plus accumulated interest. Since the seller would wait no longer, Rembrandt cast about and managed to raise the money by borrowing (Six's 1,000 guilders was one of the loans), although this of course did no more than transfer his indebtedness. In 1654 he tried to buy a much cheaper house, presumably with the intention of selling the Breestraat building and paying off some of his creditors with the profit made from the sale. But for some reason the deal fell through. By 1656 matters were clearly desperate, and in May Rembrandt attempted to transfer the house to Titus, so that the creditors could not touch it (a dishonest stratagem that is commonly used, in slightly more sophisticated forms, to this day). Having failed in this too, Rembrandt applied to the High Court for a 'surrender of goods' (*cessio bonorum*) in July 1656, and the court granted his petition.

Technically speaking, this was not a bankruptcy and was certainly regarded as rather less of a disgrace. Rembrandt's petition cited his losses by trade and at sea as the cause of his misfortunes, implying that he was the victim of impersonal forces such as storms and fluctuating markets, which might bring down the most prudent of Dutchmen. There may have been some truth in his claim, although it seems more likely that he was simply using an acceptable formula to put the best possible face on his embarrassment.

The Chamber of Insolvency was put in charge of the liquidation, and completed an inventory of Rembrandt's effects by 25 July; having made an exhaustive record of the contents of the house (to make sure Rembrandt sold nothing for his own benefit on the sly), the court could take its time about selling them off. We have already seen how extensive his possessions were. Like other

Self-portrait at an Easel. 1660. Musée du Louvre, Paris.

Self-portrait with a Palette. c.1660. Iveagh Bequest, Kenwood, London.

69

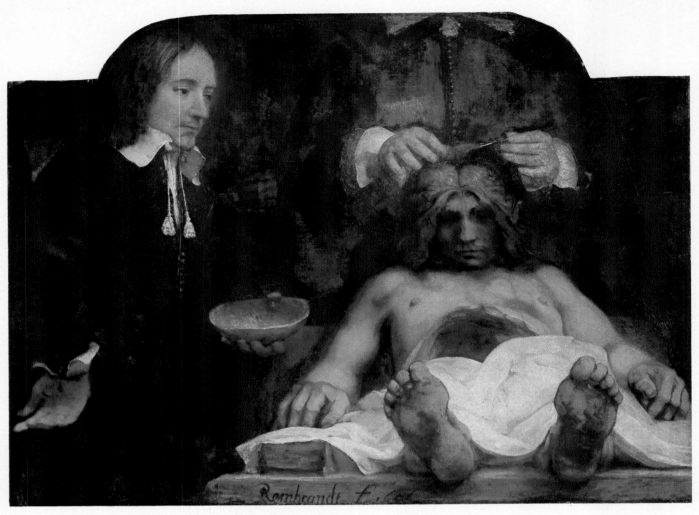

The Anatomy Lesson of Dr. Deyman. 1656. This is the only surviving fragment of a larger work; the rest was destroyed in a fire. The surgical aspect of the occasion has thus acquired an accidental prominence. The original was a group portrait in honour of the lecturer, just like *The Anatomy Lesson of Dr. Tulp.* Rijksmuseum, Amsterdam.

painters he may have made his studio double as a shop where customers could buy copies of well-known prints as well as original paintings by contemporary masters; but everything we know about Rembrandt suggests that he would have found such an activity an intolerable waste of time, and we may suspect that any 'dealing' he went in for was a disguised form of collecting. The collection was valued at 17,000 guilders, and Rembrandt may have believed that its sale would clear his debts, which seem to have totalled about 13,000 guilders. But when the auctions at last took place, in December 1657 and September 1658, prices were disastrously low; Rembrandt's household effects, paintings, prints, drawings and curiosities brought in no more than a few thousand guilders. In spite of the delay in holding them, the auctions were hastily-arranged affairs, and this may have caused the depressed prices by preventing the attendance of dealers and collectors from outside Amsterdam.

The house was the last item to go; it was sold in December 1660 for 11,218 guilders, a couple of thousand less than Rembrandt had paid for it twenty years before. He, Hendrickje, Titus and Cornelia moved to rented accommodation in the Rozengracht, at that time on the outskirts of the city. They seem to have been fairly comfortable (Rembrandt still received well-paid commissions and took on an occasional pupil) and, after the tribulations of the previous few years, peaceful obscurity may have suited very well a painter whose eyes were increasingly turned inward. Any further worries about his debts, about the hostile attitude of the Guild of St. Luke's since his disgrace, or about any other financial matters, were banished by a simple legal device. Before moving to the new premises, Hendrickje and Titus (now nineteen years old) formed a partnership as art dealers; they 'employed' Rembrandt and paid him a wage, so that any work he produced was their property — and therefore could not be seized by his creditors. In the event there was no more serious trouble, although legal wrangles continued until the mid-1660s; Titus eventually received 6,000-odd guilders as his share of the estate as Saskia's heir, and Rembrandt became sufficiently well-off to resume collecting on a modest scale.

Even in the year of his bankruptcy Rembrandt was given a commission that proved he was not a forgotten man. *The Anatomy Lesson of Dr. Tulp*, painted

70

over twenty years before, had evidently endeared Rembrandt to the surgeons of Amsterdam, who now asked him for a new 'Anatomy Lesson' to honour Tulp's successor, Dr. Joan Deyman ('Joan' is a variant of the name Johannes). Unfortunately *The Anatomy Lesson of Dr. Deyman* was later badly burned, and only a fragment survives. In its present condition the picture is dominated by the corpse, laid out at right-angles to the picture surface so that the soles of his foreshortened feet are the objects in the picture that seem closest to the viewer. He is slightly propped up so that we can see not only the gaping void beneath the rib cage, but also his face, above which the two sides of the brain can be seen, neatly 'parted', while a mass of cut scalp dangles onto both cheeks like the long hair of the assistant who stands beside him, holding the corpse's brain-pan. The gruesomeness of the painting is probably an accidental result of its fragmentary state, which concentrates attention on the dissection rather than dispersing it among the anatomist and his associates. The same may be true of the religious associations that appear to be present in the fragment; the corpse is irresistibly reminiscent of a dead Christ (even before we discover that its position seems to have been founded on just such a Christ-figure by the Italian Renaissance painter Mantegna), while Dr. Deyman's hands and the attitude of his assistant are curiously suggestive of priestly functions. Since the only record of the entire painting is the roughest of sketches (now in the Rijksmuseum), done merely to show how the picture should be framed, we cannot be certain of Rembrandt's intention; if it really was religious, it involved some associations — between a dissection and a laying-out, between anatomists and celebrants — that are distinctly odd and uncharacteristic.

A more straightforward masterpiece, also dating from 1656, is *Jacob Blessing the Sons of Joseph*. In the biblical episode, Joseph brought his sons Manasseh

Jacob Blessing the Sons of Joseph. 1656. A curiously tranquil rendering of the biblical story in which Jacob insists on giving the younger of his grandsons his first blessing, foreseeing the boy's future greatness. Staatliche Kunstsammlungen Kassel, Gemäldegalerie.

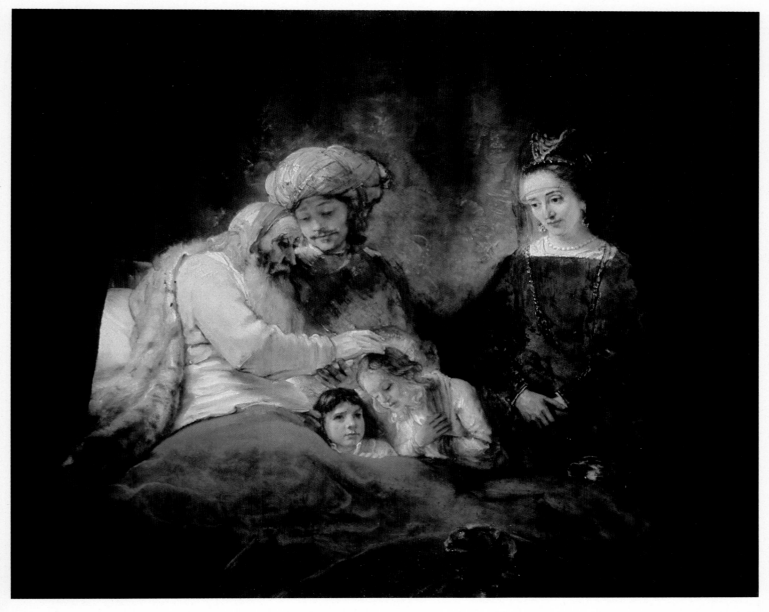

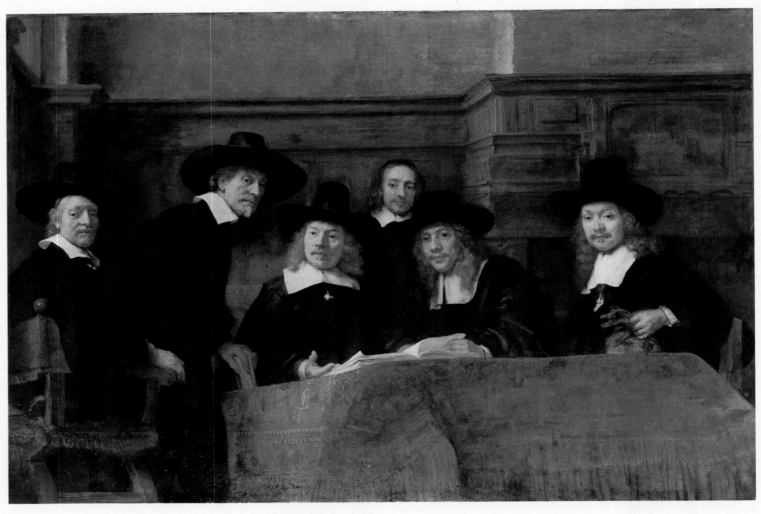

The Syndics of the
Drapers' Guild.
1661. The last and
greatest of
Rembrandt's group
portraits. These
sampling officials,
'interrupted' by the
spectator in the
middle of a
discussion, have an
awesome gravity.
Rijksmuseum,
Amsterdam.

and Ephraim to be blessed by their grandfather, the patriarch Jacob. Instead of blessing the elder with his right hand and the younger with his left, as custom dictated, Jacob crossed his hands so that his right hand blessed Ephraim, the younger. When Joseph protested and tried to move his father's hand, Jacob would not allow him to do so, prophesying that Ephraim would be the greater of the two brothers. Frankly, the story is hardly relevant to the painting, and most explanations have an air of special pleading, for Jacob is not crossing his hands (a detail that Genesis emphasizes), Joseph does not look the least bit displeased and seems to be guiding rather than pulling away his father's hand, and Rembrandt has wilfully introduced Joseph's wife, Asenath, into the scene in order to make up a balanced family group. In reality, the painting is primarily a celebration of the family, rather lighter in spirit than many of Rembrandt's works, and appropriately lighter in colour tones — Rembrandt's favourite reds, yellows and browns predominating in a wonderfully harmonious scheme. Somehow the fancy-dress elements (Joseph's turban, Asenath's strange head-dress) do not spoil the mood, and it even survives the extreme sentimentality with which the children are portrayed.

The Syndics of the Drapers' Guild (1661) was another major commission of Rembrandt's later years. It was also his last and greatest group portrait, at first glance quite straightforward but on closer scrutiny a superb composition and a dramatic masterpiece. Rembrandt realized that some kind of tension was needed to give interest to a group portrait of sober citizens, except where, as in the Anatomies, there was a corpse to do the job for him. In The Night Watch he had transformed the portrait into a scene of mustering and bold, soldierly setting-out; but that option was not open to him in painting men with no pretensions (as a group, at any rate) to anything but commercial probity and acumen. Rembrandt solved the problem brilliantly by posing them as though they had been interrupted in the middle of guild business, going over accounts or reports; most of them are staring at whoever has just come through the door (that is, at the viewer outside the picture) with that neutral, intimidating scrutiny known to every job applicant. There are five of them, splendidly dressed in black cloaks and coats with huge white collars, and wearing broad-

brimmed hats (all right-minded Dutchmen wore hats indoors); behind them stands some lesser being — perhaps a clerk — with bared head, plain tunic and respectfully small collar. The naturalness of the grouping is such that the picture appears not to have been composed at all — which is, perhaps, the highest order of composition. But a brief examination makes us realize the importance of the off-centre view of the scene with which we are presented; we do not look straight down the table at the group, but from a position slightly to the left, so that one corner of the table juts out at us and each of the Syndics is seen from a slightly different angle. We get one glimpse of the creative process in the contrast between a preliminary drawing that Rembrandt made of a Syndic standing upright, and the same man as he appears in the completed painting, still standing but now shown leaning over towards his colleagues, powerfully reinforcing our sense that we are confronted by a close-knit group rather than an arbitrary collection of individuals. But although analysis of this kind may help us to understand the technical side of Rembrandt's art, no analysis has successfully explained how its human quality is achieved. As so often in his work, *The Syndics* makes us believe in the moral weightiness of humanity. In this instance, a group of wealthy drapers are transformed into exemplars of vigilant, responsible authority; they might equally well be the masters of the world, gravely deciding the fate of nations.

The Syndics was a masterpiece that probably also pleased its buyers, but Rembrandt was not always so fortunate. *The Conspiracy of Claudius Civilis* (1661–62) was the greatest public commission he ever received, and yet he painted it in a manner he must surely have known would not be well received. He was not even first choice for the job, which was part of a grand decorative scheme for Amsterdam's splendid new Town Hall. Eight huge paintings were required for the south gallery, and it was originally intended that they should all be done by Govaert Flinck, a former pupil of Rembrandt's who had made a successful career as a suave portraitist. After Flinck's sudden death in February 1660, it was decided to split up the commission; Rembrandt himself, and his old friend Jan Lievens, were among the painters chosen to contribute. The eight paintings were to form a historical cycle narrating the revolt of the Batavians against their Roman masters in the 1st century A.D. The Batavians were a Germanic tribe who settled in the Rhine delta, and whom the Dutch therefore regarded as their ancestors; so the civic authorities of Amsterdam clearly wanted a series of straightforward heroic paintings that would glorify the Batavians and perhaps arouse memories of the more recent and successful Dutch revolt against imperial Spain.

Rembrandt gave them something wilder, stranger and more barbaric than they were prepared for. His brief was to paint the first episode of the story, perhaps because it was thought that a night scene would suit his 'dark' manner. According to the Roman historian Tacitus, who was the source for the whole story, a Batavian chief whom he calls Claudius Civilis invited the other tribal chiefs to a nocturnal banquet and plied them with drink and oratory until they

Above: *Homer*. 1663. Painted for Rembrandt's Sicilian client Antonio Ruffo, who complained that it was not properly finished and sent it back for Rembrandt to do more work on. This is only a fragment of the original, badly damaged by fire, which showed the Greek poet teaching or dictating to two disciples. Mauritshuis, The Hague.

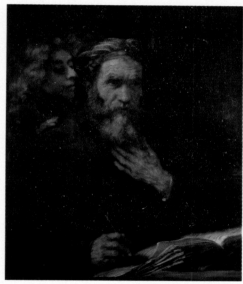

Above: *St. Matthew and the Angel*. 1661. The angel is evidently inspiring the evangelist as he writes his Gospel. Musée du Louvre, Paris.

Left: *The Conspiracy of Claudius Civilis*. 1661. Originally intended as part of a decorative scheme for the new Amsterdam Town Hall, Rembrandt's painting was rejected, and he then cut it down to its present size in the hope of finding a private buyer. The picture shows the Batavians – legendary ancestors of the Dutch – swearing an oath to resist the Romans. Nationalmuseum, Stockholm.

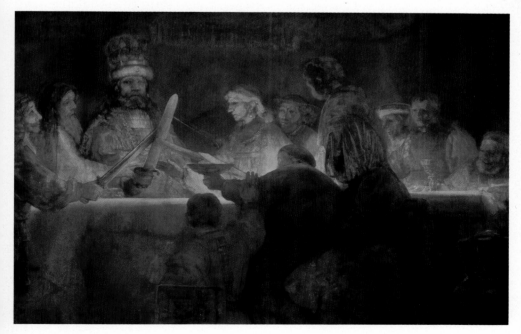

73

Right: *Portrait of Jacob Trip*. 1661. Trip was a Dordrecht merchant. The painting is a companion-piece to the painting on the following page. National Gallery, London.

Above: *Portrait of Gérard de Lairesse*. 1665. De Lairesse was a fellow-painter, at this time aged twenty-five. Lehman Collection, New York.

swore a great oath to join him in rebellion. Rembrandt paints the very moment of oath-taking, dramatizing it by representing the assembled chiefs holding their unsheathed swords against the large broad blade of their leader's weapon. The picture was the largest Rembrandt ever painted, about 16 feet by 16 feet (488 cm by 488 cm). It was hung in the Town Hall but must have been removed soon afterwards and returned to Rembrandt, who cut it down to its present size, about 6 feet by 10 feet (183 cm by 305 cm), presumably in the hope of finding a private purchaser for what was still a very large painting. Rembrandt's *Conspiracy* was replaced in the Town Hall by a work from the hand of Juriaen Ovens, one of his own pupils.

It is not difficult to imagine why the *Conspiracy* was disliked. Instead of a heroic event, Rembrandt makes the night-meeting a rather sinister occasion; instead of handsome heroes, he gives us real barbarians. Tacitus mentions that Claudius Civilis had lost an eye, and all the painters involved in the Town Hall project therefore showed him in profile, thus respecting history while sparing the viewer; Rembrandt alone painted the chief so that the empty socket could be seen. But the picture is not a piece of accurate (or even would-be accurate) historical reconstruction; it is far stranger than that. It has the quality of authentic myth or folktale. One-eyed Civilis is much larger than his fellow chiefs, looming in his scarcely articulated bulk like some fearsome totem crudely carved out of wood; his curious pineapple crown, as big as his head and seemingly glued down onto it, reinforces the impression. The table around which the chiefs sit

74

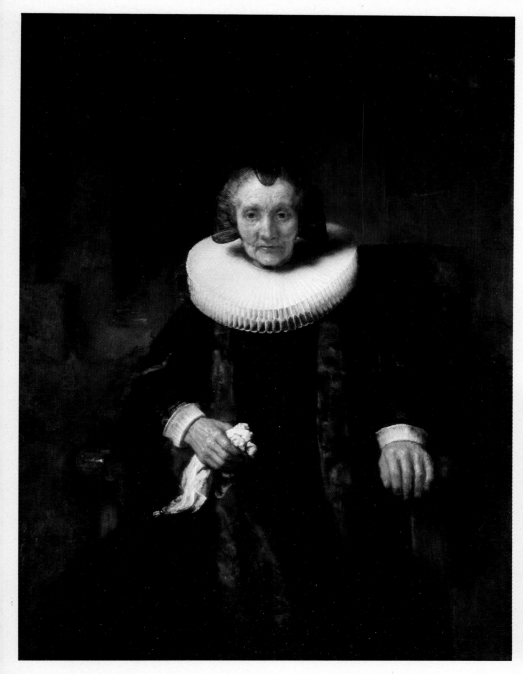

Left: *Portrait of Margaretha de Geer.* 1661. This is the companion-piece to Rembrandt's portrait of Jacob Trip, Margaretha's husband. This Dordrecht couple were old clients of Rembrandt's. National Gallery, London.

Above: *Portrait of Margaretha de Geer, bust length.* 1661. National Gallery, London.

is like a bar of light, eerily illuminating them from below; and their faces are for the most part grotesque or cartoon-like. Trolls, dwarfs and similar creatures of northern fantasy would not be out of place in the scene. The *Conspiracy* is a strange painting, and one can hardly blame the civic authorities for not wanting to include it among the daytime splendours of their new Town Hall.

However indifferent he may have become to general opinion, Rembrandt must have felt humiliated by this public rejection. Yet his work was still in demand; the Drapers' Guild wanted it, and Don Antonio Ruffo of Messina remained a good client to the end. True, Ruffo had a row-by-correspondence with Rembrandt over the *Alexander* and *Homer* paintings Rembrandt sent him in 1661–63, but the artist was conciliatory and did a new version of at least one of them. Artist and client evidently remained on excellent terms since, in 1669, the year of Rembrandt's death, we find Ruffo ordering almost two hundred of his prints. The Dordrecht couple Jacob and Margaretha Trip were also long-time customers; in 1661 Rembrandt painted superb companion portraits of them in their old age, and an additional non-matching portrait of Margaretha. He even remained enough of a public figure to be worth visiting, most notably by Cosimo de' Medici, later Grand Duke of Tuscany, who took one of Rembrandt's self-portraits back to Florence with him.

However, Rembrandt's final years must have been quiet ones, shadowed by personal losses rather than public controversies. Hendrickje made her will in 1661, when she was ill; she left her possessions to Cornelia, stipulating that

75

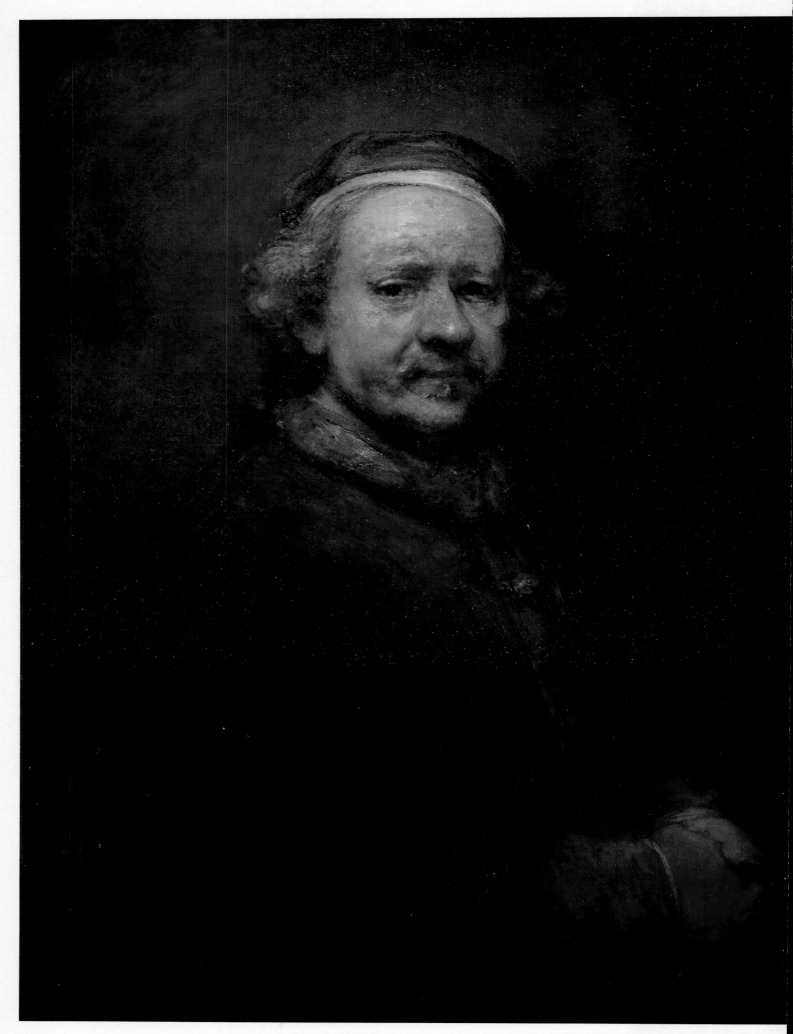

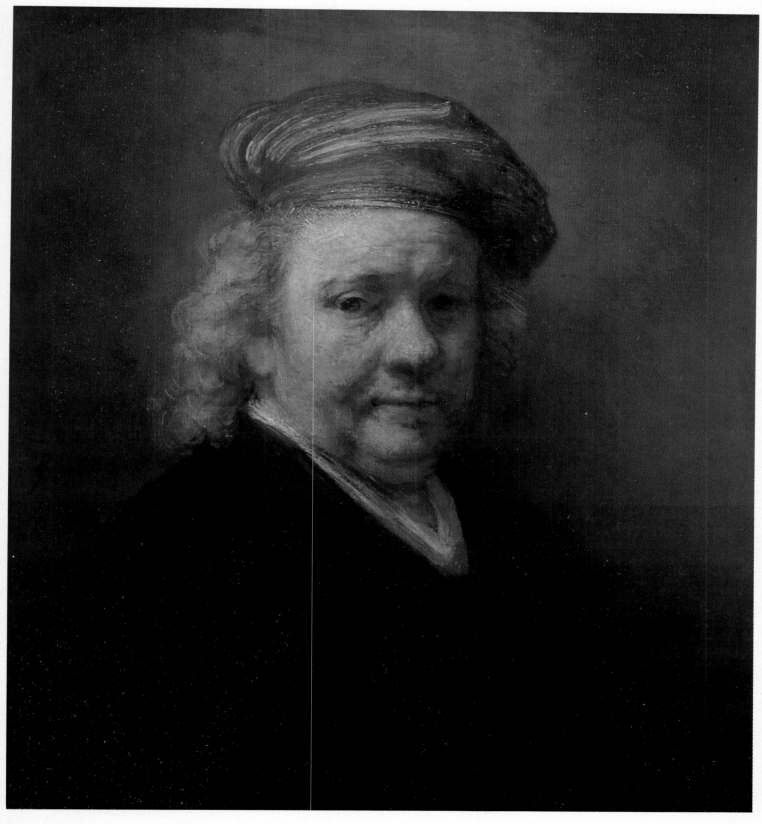

Titus should have them in the event of the girl's death. Hendrickje died on 24 July 1663 and was buried in the local church, the Westkerk. Titus married in February 1669, when he was twenty-seven, but died a few months later; he too was buried in the Westkerk. But he had a posthumous daughter (called Titia) by his wife Magdalena, a fact that presumably complicated the last months of Rembrandt's life. He himself died on 4 October 1669, still only sixty-three, of causes unknown or unrecorded.

He had gone on working to the end, although he appears to have given up etching some years before (perhaps his hand was no longer steady enough — or his eyesight good enough — for such fine, close work). His self-portraits record the bloating and falling of his flesh with seeming dispassion; curiously enough, it was only in the 1660s that he occasionally painted himself at work,

77

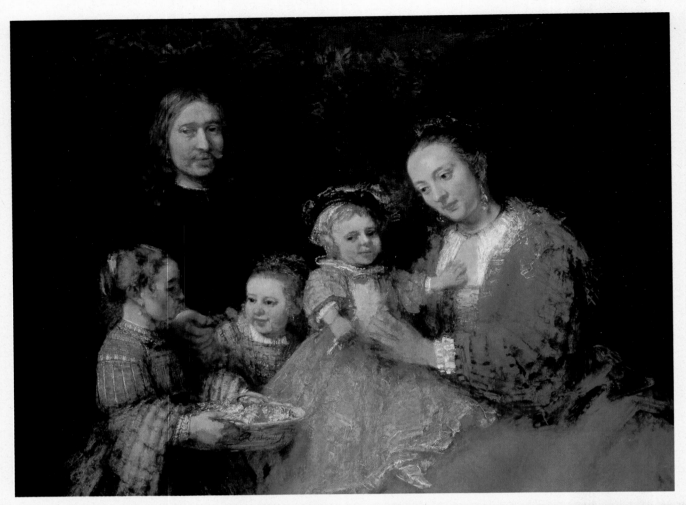

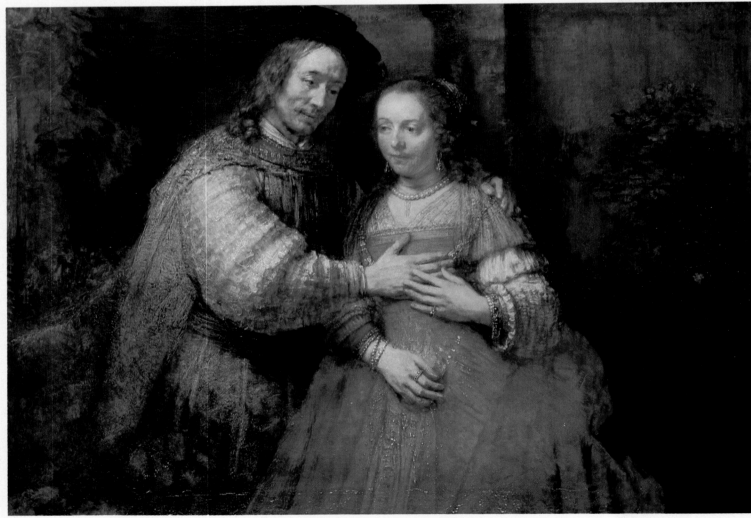

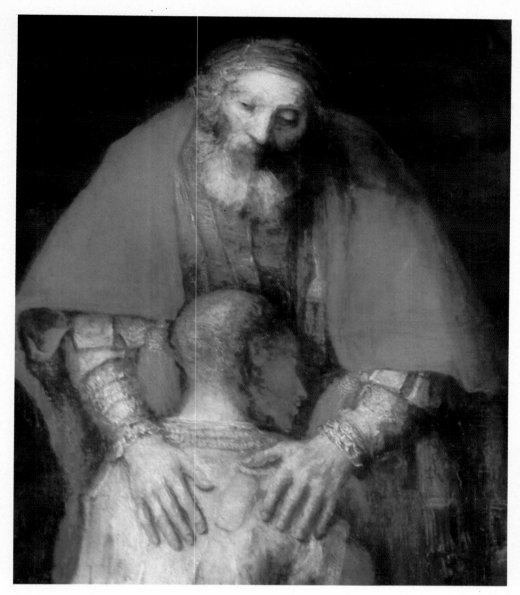

Left top: *Family Group*. A late painting (*c*.1668), possibly of Rembrandt's daughter-in-law Magdalena and some of her relations. Herzog Anton-Ulrich Museum, Brunswick.

Left: *'The Jewish Bride'*. *c*.1665. The title is traditional and possibly inaccurate, but the emotional subject of this wonderful painting is universal. Rijksmuseum, Amsterdam.

Left: *The Return of the Prodigal Son*. *c*.1668(?). One of Rembrandt's last paintings, on a theme which he had tackled many times. It is perhaps the most tender work in the history of art. Hermitage Museum, Leningrad.

holding brushes, palette and mahlstick (the 'rest' used by a painter to hold his hand steady). We know nothing of Rembrandt's outlook in his last years, but if the atmosphere of his late works can be taken as evidence, he felt resigned and reconciled, loving and forgiving his neighbour. *The Jewish Bride* (*c*. 1665) and *The Return of the Prodigal Son* are perhaps his most sublime paintings, richly coloured, richly worked, yet in appearance utterly simple. *The Jewish Bride* is sometimes, more helpfully, called *The Bridal Couple*; the episode may or may not be biblical, the bride may or may not be Jewish (both questions are controversial), but the tender attitudes of the protective groom and trusting bride are meaning enough, making it unnecessary to locate the painting in time and space. *The Return of the Prodigal Son* may be one of Rembrandt's very last works. In it he goes back to a biblical episode that seems to have obsessed him, though we do not know enough about his inner life to even guess at the reason. Here he makes less emotional play with the Prodigal's degraded state than he did in earlier efforts; the close-cropped head and worn shoes tell us all we need to know about that. The overwhelmingly important event is the long-overdue meeting between father and son. The moment is one of rapture and relief; we can see the Prodigal kneeling, from behind, one of his soles bared — a telling detail that lets us know he has flung himself down with such joyful violence that one of his slip-on shoes has fallen off. The Prodigal nestling his head against his father's heart, the father's hands resting on his son's shoulder and back, are supreme examples of Rembrandt's final tenderness, made all the more touching by the impassiveness with which the onlookers (presumably unforgiving relatives) watch what is happening. The biblical and the ordinary worlds are brought together once again, ennobling the ordinary and celebrating the wide soul of man. We cannot say that the *Prodigal* was Rembrandt's last completed painting, but it would be entirely fitting if it proved to be so. It might well stand as his final statement to the world.

79

Acknowledgments

The illustration on page 17 is reproduced by Gracious Permission of Her Majesty Queen Elizabeth II. The illustrations on the following pages are reproduced by permission of the Trustees of the Chatsworth Settlement 13, 56, 57 top, 57 bottom; page 69 right by permission of the Greater London Council, Trustees of the Iveagh Bequest, Kenwood; and page 23 by permission of the Provost and Fellows of Worcester College, Oxford.

Art Gallery and Museum, Glasgow 12 bottom, 19 left; Ashmolean Museum, Oxford endpapers; Barber Institute of Fine Arts, Birmingham 53 bottom; Bildarchiv Preussischer Kulturbesitz, Berlin 20, 47, 49 top; Blauel, Munich 41 left; Boymans-van Beuningen Museum, Rotterdam 8 bottom, 61 left; Frans Halsmuseum, Haarlem 24; Photographie Giraudon, Paris 14, 15, 36, 39, 40, 54, 55 top, 55 bottom, 58; Garanger-Giraudon 29; Lauros-Giraudon 60 left; Hamlyn Group Picture Library 10 bottom, 12 top, 18 top, 19 right, 26 left, 32, 33, 41 right, 42, 43, 45, 46 right, 48, 52 top, 59 right, 60 bottom, 61 right, 65, 66, 67 bottom, 67 right, 69 left, 69 right, 73 bottom right, 74 left; Herzog Anton-Ulrich Museum, Brunswick 78 top; Mauritshuis, The Hague 6, 16, 27, 30, 35, 63, 73 top right, 77; National Gallery, London 7, 22, 37, 50, 51, 64, 68, 74 right, 75 left, 75 right, 76; National Gallery of Ireland, Dublin 28–29; National-museum, Stockholm 73 bottom; Novosti, London 38 left; 46 left, 53 top, 79; Rijksmuseum, Amsterdam 21, 26 right, 44–45, 70, 72, 78 bottom; Royal Pavilion, Art Gallery and Museums Brighton 34; Staatliche Kunstsammlungen Dresden 10 top left, 10 top right, 38 right, 49 bottom; Staatliche Kunstsamm-lungen Kassel 18 bottom, 52 bottom, 71; Walker Art Gallery, Liverpool 31; Wallace Collection, London 8 top, 9, 11, 25, 59 top, 62.

Front cover: *Simeon in the Temple*. 1631. Oil on canvas. Mauritshuis, The Hague.
Back cover: *Self-portrait*. 1657. Oil on canvas. Duke of Sutherland Collection, on loan to the National Gallery of Scotland, Edinburgh.
Endpapers: *The Artist's Father*. 1630. Ashmolean Museum, Oxford.
Title spread: *The Prophet Jeremiah Lamenting the Destruction of Jerusalem*. 1630. Rijksmuseum, Amsterdam.